Leonardo da Vinci's Advice to Artists

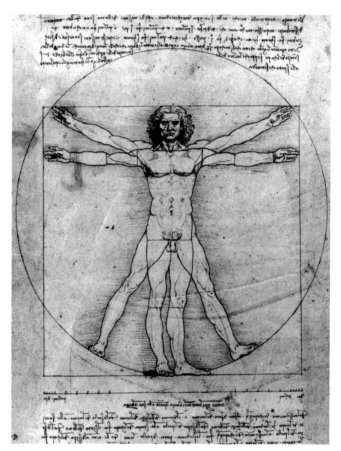

Diagram of human proportions, 1485–90. Accademia, Venice.

Leonardo da Vinci's Advice to Artists

Drawings by
Leonardo da Vinci

Edited and Annotated by
Emery Kelen

Running Press
Philadelphia, Pennsylvania

9 8 7 6 5 4 3 2 1

Digit on the right indicates the number of this printing.

Library of Congress Cataloging-in-Publication Number: 89-43592

ISBN 0-89471-834-7

Picture Editor: Gillian Speeth
Cover design by Toby Schmidt
Interior design adapted by Dennis Roberts
Cover photograph: *Mona Lisa*, 1503. Louvre, Paris. Scala/Art Resource, New York.
Back cover photograph: Detail from half-length of an apostle
(St. Peter?); study for *The Last Supper,* 1495-97. Albertina, Vienna.
Art Resource, New York.

Photographs: pages 26, 28, 32, 36, 44, 48, 59, 66, 69, 70, 84, 87, 101, 106, 120, 128 and 138, Alinari/Art Resource, New York; pages 74 and 88, Art Resource, New York; pages 39 and 54, The Bettmann Archive, New York; pages 40, 47, 62, 73 and 94, Giraudon/Art Resource, New York; pages 34, 57, 58, 78 and 80-82, The Granger Collection, New York; page 50, Lauros-Giraudon/Art Resource, New York; page 79, Photo Researchers, New York; pages 1, 20, 51, 91, 98, 100, 104, 112 and 134, Scala/Art Resource, New York.

This book may be ordered by mail from the publisher. Please add $2.50 for postage and handling for each copy. *But try your bookstore first!*

Running Press Book Publishers
125 South Twenty-second Street
Philadelphia, Pennsylvania 19103

To My Wife Betty

Also by Emery Kelen

Dag Hammarskjold: A Biography
Fifty Voices of the Twentieth Century
Hammarskjold: The Dangerous Man
Hammarskjold: The Political Man
Mr. Nonsense: A Life of Edward Lear
Peace in Their Time
Peace Is an Adventure
Proverbs of Many Nations
Stamps Tell the Story of Space Travel
The Temple of Dendur

Edited and annotated by Emery Kelen
Fantastic Tales, Strange Animals, Riddles, Jests, and
Prophecies of Leonardo da Vinci

Contents

Leonardo da Vinci's Advice to Artists

Introduction
Everyone Is an Artist

T H E day a child becomes old enough to hold a pencil, he begins to scribble on a piece of paper, and he is happy with the marks he makes. As he grows and becomes interested in his world, he draws men, women, cats, dogs, trees, houses, and automobiles. True enough, in a small child's drawing a man's arms might grow out of his neck, or the head might look like a pumpkin; but intelligent observations will be made as well: men have eyes, a nose, a mouth turning up or down, a belly, and two legs; cats and dogs have four legs and tails; trees have branches; cars have wheels and houses have windows, doors, and roofs. There isn't a child born who does not love to fix on paper his minute and scientific observations of the world around him.

Why do children draw? Why does anyone draw? Why did the caveman decorate the walls of his cave and Eskimos carve sea lions out of driftwood? Man feels an inbuilt joy when he turns the concepts of his mind into visual images. It is what sets a child to building sand into castles; the emotion he feels when he sees his castle standing there, so solid and brave, is artistic satisfaction. When he cuts paper into a flower and admires its color and shape, he is filled with aesthetic delight.

Joy in such feelings drives primitive people to tattoo their bodies and to insert chicken bones in their nosewings. It impels the fastidious Japanese to arrange colored stones in exquisite patterns on marble trays. Sheer love of life also can be a driving force for art: the desire and need to hold on to a precious object or a triumphant moment that otherwise would surely fade. Just so, the caveman painted the mammoth that got away or the hunting scene he had enjoyed and wished to remember always. It is for this reason that the child draws over and over again his dog and his house.

So everybody is really, in his bones, an artist, and Leonardo da Vinci's remarks on his profession are for everyone with eyes. This book contains some of the notions about art that he expressed in his *Treatise on Painting*. Other ideas come from the manuscripts that grew out of the ever-ready notebook, which was always dangling from Leonardo's belt.

Leonardo, the illegitimate child of a peasant girl and a notary public, was born in 1452, in Vinci, near Florence, Italy. For the first years of his life, he lived with the woman Caterina, who might have been his mother; later he moved into the house of his paternal grandfather who, in his tax declaration, listed him as a *bocca*—a mouth—that had to be fed. So our first record of the Universal Genius is as a tax deduction.

In those days not too much fuss was made about illegitimacy, and so, when Leonardo's father, Ser Piero, married, the child was brought up in his household. From the first Leonardo was clever with a pencil, and when he was fourteen, Ser Piero made arrangements for him to enter the studio of the artist Verrocchio in Florence. No doubt some

of the precepts in this book were learned from Verrocchio.

Even in Leonardo's early years people noticed his amazing versatility. Leonardo never practiced only one branch of art, but all those for which drawing was the basis: sculpture, architecture, engineering. While still a young man, he designed flour mills and machines, and even drew up plans for making the River Arno into a navigable channel between Pisa and Florence.

When Leonardo was about thirty, he went to work for Lodovico Sforza, ruler of Milan, who was called Il Moro, "the Moor," for his dark complexion. Leonardo spent sixteen years in this employment, acting as court jack-of-all-trades. He was not only painter and sculptor, but musician, storyteller, organizer of parades and charades, and designer of costumes, sceneries, and all the court's pleasures, and in sterner hours he invented amazing war machines with which Il Moro dreamed of conquering the world.

Leonardo's notebook was always at his belt, and in it he scribbled anything that struck his mind. His interests dwelt on just about anything under the sun. In one modern compilation of these notes I have counted seventy-nine different subjects on forty-nine pages, among them a comparison of the movement of the tides with the passage of air in the lungs and observations on the increase in the size of the pupils in the eyes of an owl, a man, and a cat; on the problem of squaring the circle; on how the earth's surface is increased by the growth of vegetation; on what the wings of a flying machine ought to be like; and on the measurements of a Sicilian horse.

Such random scribblings sketch out for us the musings of

an almost transcendent mind; he wrote on art, physiology, philosophy, hydrography, ethics and morality, and sometimes his ramblings seem to spill over the edges of ordinary thinking, so that they cannot be understood at all. Such dissertations appear side by side with a recipe for perfume, with household accounts, with expenditures for the funeral of a woman, Caterina, or with the cold and stark, "At 7 A.M. on Wednesday, July 9, 1504, Ser Piero da Vinci, my father, notary to the Podesta, died. He was eighty years old and left ten sons and two daughters."

Having had little education—a fact of which he was ashamed—Leonardo was not a smooth and stylish writer. His grammar, as one of his biographers, Eugène Müntz, has said, was "that of a Florentine shopkeeper." His spelling was terrible, and he stuck words together that were supposed to stand apart. In addition to these orthographic complications, he had a fancy amounting to an inner compulsion to write in puzzles and riddles. If he wanted to write that he was going to Rome—*a Roma*—he wrote *a morra;* to Naples—*a Napoli*—was *in lo panna.* In addition to such more or less playful obfuscation, Leonardo habitually wrote with his left hand in mirror writing—from right to left on the page. This fact has wrung many a shudder and sigh from Leonardo scholars, who have tackled the task of deciphering and bringing order to this deplorable morass of words.

Because the literal translations of these writings are labored and repetitious, as was the original, and come to us in antique language with strange idioms that make his meanings knotty, the everyday wit and wisdom of Leonardo da

Vinci are not at all well known. Yet he was a witty man as well as a wise one, and he never ceased to pour out his thoughts on paper. He could be mordant, even sarcastic. The melancholy humors that plagued his life often made him acidulous and cast a shadow over his profound humanity.

The writings in this book have been selected, simplified, and honed down, but I hope that I have kept the essential thoughts and preserved a feeling of the sort of man he was, at least as an artist—that is, a passionate observer, a lover of what the eye sees. It is odd that while he loved to write in codes, riddles, and puzzles, he was absolutely direct in everything he saw and drew. His remarks on visual phenomena are perhaps among the plainest and clearest of all his writings.

One of the burning questions that agitated the minds of the swarms of poets, musicians, playwrights, and artists who inhabited the court of Il Moro was: Whose art is the loftiest? Interested in such bickerings, Il Moro prompted his charade master to write a comparison of sculpture and painting. Leonardo had no doubt where he stood in the argument: painting was the best of the arts. Poetry could be eliminated with a flourish. "The works of a boilermaker last longer!" he said, and he scribbled down a good retort to some poet: "You can call painting dumb poetry if you like, but then I'll call poetry blind painting. Well, what's worse, to be dumb or blind?"

"The poet might inflame men with love," he wrote, "but then, so can the painter. The lover can even kiss and speak to pictures, which he would hardly do to the written word."

Leonardo da Vinci's Advice to Artists

When writing about sculpture, Leonardo bit deeper. "Sculpture is less intellectual than painting, lacking many of its natural subtleties." A piece of sculpture needs to be placed in a certain light, while painting carries everything in itself of light and shade. "One of the chief skills of a painter is learning how to make his picture look like relief. Sculptors don't need this: the nature of their work produces the relief."

Sculpture is the more enduring, but painting is more beautiful.

Besides, said Leonardo, who was a fastidious man about his dress and grooming, sculpture is dirty, and so are sculptors, whose faces are forever begrimed with dust, grit, and sweat. A painter is more seemly in his surroundings, he continued; indeed, musicians might well play to him while he works—and so they did, when he painted the "Mona Lisa." To the argument that a work of sculpture is the living shape of the model, Leonardo replied that painting is just as lifelike and natural, and that he had seen with his own eyes children holding out their arms to portraits of their father and dogs barking at pictures of other dogs.

Michelangelo, who was not elegant and did not like Leonardo, had a comment on these opinions when he was told of them: "Oil painting is for women and for mules."

Inspired by his notes on this argumentation, Leonardo began to record observations on art in general and advice to artists. His notations ranged from remarks on quite mundane, commonplace visual phenomena, such as "Black objects look larger against a white ground," to abstruse and subtle assessments of what must happen to a body when it

shifts weight. Sometimes he would describe a rather beauti-
ful effect with cold, technical objectivity. Other times he
would suddenly soar with his high-winging mind over the
idea of a mountain range against the horizon or of a tree in a
fog—things we have seen a thousand times, but which come
as a novelty and evoke really stunning images when ob-
served through his eyes.

Leonardo's warmest feelings bloom in his remarks on
natural objects and the countryside, Nature's very breast, and
perhaps some artists who have read these remarks will never
again go for a walk without walking with Leonardo.

He was about forty when he began to compile his notes,
many of them obviously directed toward the pupils of his
studio. Quite often his tone is paternal. If we want "to climb
a tower," he admonishes, "we must be content to proceed
step by step, otherwise we will never get to the top." He
appears to have been an understanding, painstaking teacher,
who had a firm, noncomplaisant attitude toward people who
did not want to do their homework. Knowing full well that
good painting has good drawing behind it, he forbade
youths under twenty to use paints at all, insisting that they
learn to draw first. "A young painter must first get used to
copying the drawings of good masters," he said, "and only
when his hand is formed and ready, he may, with the guid-
ance of his teacher, proceed to drawing from relief." But no
brushes, no water, no glorious shining oils.

Every man is an artist; there is no question about that.
But Leonardo understood that while many people can draw,
and love to draw, and might even desire to draw better,
they still might not have the sheer dedication to be artists in

the great and grand tradition, to have no regard for worldly gain, to starve in garrets for art's sake.

How can you tell when there is no real stuffing in young artists? "You can see it immediately," wrote Leonardo, "in their want of perseverance. They are like little children who draw everything in a hurry, never finishing, never putting in the shadows."

When Leonardo died in 1519, aged sixty-seven, he left his notebooks—about five thousand written pages of them—to Francesco Melzi, who had been his assistant for some years. It was Melzi who, with the assistance of three others, compiled the *Treatise on Painting*, copying faithfully and painfully from the mirror writing and, it is believed, correcting some spelling mistakes. It is a rather scrappy compilation from what was probably incomplete source material to begin with. The most complete form we have of it is contained in the Codex Urbinas 1270 in the Vatican Library. The other remarks of Leonardo on painting and related subjects included in this book are from the manuscript now in the library of the Institut de France in Paris. The manuscript is there because when Napoleon entered Milan at the head of a victorious army, he declared that "All men of genius . . . are French, whatever the country which has given them birth." Accordingly, he pronounced Leonardo's manuscripts in Milan's Ambrosiana Library French and sent them off to Paris.

After Napoleon's defeat, Pope Pius VII sent the painter Canova to Paris to negotiate with the French for the return of the works of such sudden Frenchmen. For some reason

the Leonardo manuscripts in the institute were overlooked, and so they remain there to the present day.

The *Treatise on Painting* was first published in Paris in 1650, and another edition, with its text from the manuscript in the Vatican Library, was issued in Italy in 1817.

From these jottings, both practical and wonderful, we cannot learn how to paint like Leonardo, but we can learn how he thought a great artist should think. Many of these observations were being expressed for the first time in history. They fixed ideas that had never been fixed before and stretched the mind on to new tracks. Some of them are rather difficult and have to be read over a few times. Leonardo was, after all, not only a peerless artist but a scientist and technologist as well, and he drew no distinction between the disciplines.

One of his precepts, however, may sum up in a few words all of his thoughts about art, science, or technology, and perhaps it is the only thing that any artist need know, whether he is a child scribbling, an Eskimo carving, a wild man tattooing, or a painter starving. These words are: *Choose only one master: Nature.*

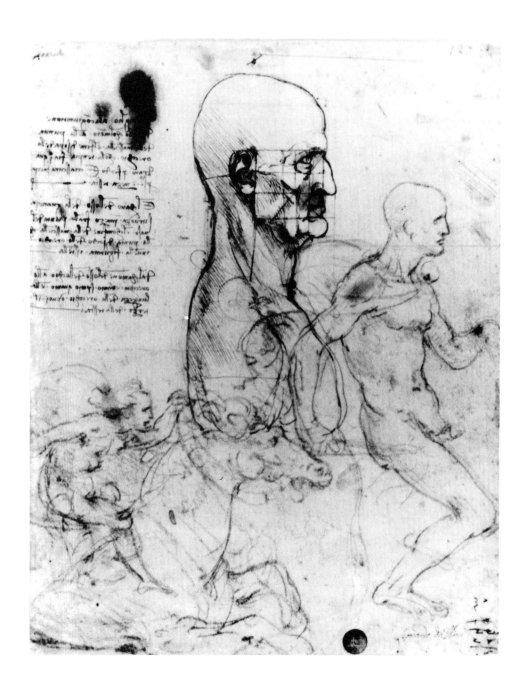

I Art and the Young Artist

When we read Leonardo's random notes reflecting on his profession, it is entertaining to sense the various moods in which he scribbled them. Sometimes he is being the stern preceptor, counting rules on his fingers, sometimes the compassionate master of a young pupil who is horrified by what he has put on canvas, or the self-examiner, or the poet. Now and then we find him bursting into a great exultation about his art, placing it in the very lap of Mother Nature and the artist within a breath of God. Remembering that he was a poor man, with no stature in his society, who walked among lords in a fancy coat, we can only admire his thundering pride as an artist. Of course, artists must have such pride; they cannot draw without it, or without the feeling of being somehow set apart.

All the same, though he was not a polished writer, he was choosy about his words and did not use the expressions creative art *or* artistic creations *which are commonplace today; he considered them arrogant and preferred the word* generate. *God creates. Man is only the*

Study of human physiognomy and of horsemen, 1490–1504. Accademia, Venice.

Leonardo da Vinci's Advice to Artists

energy that arranges, according to his ability, the created objects that are placed before him, and thus passes them on to the understanding of others.

Sound rules are the children of sound experience, which is indeed the mother of all the sciences and arts.

Painting is concerned with the ten things you can see; these are: darkness and brightness, substance and color, form and place, remoteness and nearness, movement and rest.

The organ of sight is quick and takes in at a glance an infinite variety of forms; nevertheless it cannot really grasp more than one object at a time. The reader, glancing down this page, sees at once that it is covered with different characters, yet he cannot at the same moment distinguish the letters, still less comprehend their meaning. He must go word by word, line by line, if he wishes to understand them. . . .

To the young man with a natural inclination for art, I would say: in order to acquire a true notion of the form of anything, study it part by part, never passing to a second till you have well practiced the first, storing it away in your memory. Otherwise, you will be wasting your time and your studies will drag on and on. Remember: acquire accuracy before speed.

22

It is no great thing to learn to do one thing well, such as a head, a nude, an academic figure, or draperies, animals, landscapes, any special subject. There is hardly anyone so stupid that he would fail if he applied himself earnestly to one thing, practicing continually.

Know the . . . proportion in man and other animals; and also make yourself a good architect; and know the forms of all things on the earth, in their infinite variety. The more you know, the better you will paint.

In drawing, consider three things: first the position of the eyes that see; second the position of the object seen; and third the position of the light that illumines the object.

It is not enough to believe what you see, you must also understand what you see.

A painter ought always to have in his mind a kind of routine system to enable him to understand any object that interests him. When he sees it, he should stop and take notes on it; he should make a statement about it to himself. He should consider the place, the circumstances, the lights and shadows.

Consult Nature in everything and write it all down. Whoever thinks he can remember the infinite teachings of Nature flatters himself. Memory is not that huge.

Painters must study the universal laws of Nature and ponder much on everything; and select always the truest examples of

every sort of thing. By this means his mind will become like a mirror, reflecting truly everything before him; it will become, as it were, a second Nature.

Painting is the sole imitator of visible Nature, that is, all forms, seas and fields, plants and beasts, grass and flowers, and every other thing surrounded by light and shade. Thus painting is a science, a legitimate daughter of Nature—or perhaps we might call it a grandchild of Nature, for Nature creates visible things, and a painting springs from created things.

Thus painting is a grandchild of Nature. It is related to God.

A painter should be a solitary. Solitude is essential to his art. Alone, you belong to yourself only; with even one other person you are only half yourself, and you will be less and less yourself in proportion to the number of companions.

When painting, it is much better to draw in company than alone. For one thing, you will feel ashamed to be among draftsmen who are better than you are and this commendable envy will serve you as a spur to better yourself. Besides you'll absorb something of the style of anyone whose work is better than yours.

There is a danger in copying the style of another painter: it leads to mannerism. Mannerism excludes naturalism.

Do not imitate one another's style; if you do, so far as your art is concerned you will be called a grandson, rather than a son of Nature.

Everybody makes mistakes at first; and if a painter never learns what his mistakes are he will never correct them. Therefore test your work; and if you have made mistakes correct them; and don't make the same mistakes again.

I have had no small benefit when in bed in the dark from retracing in my mind the outlines of those forms I had been previously studying, particularly those that seemed to me most difficult to grasp and remember. In this way they become firmly established in the mind and stored in the memory.

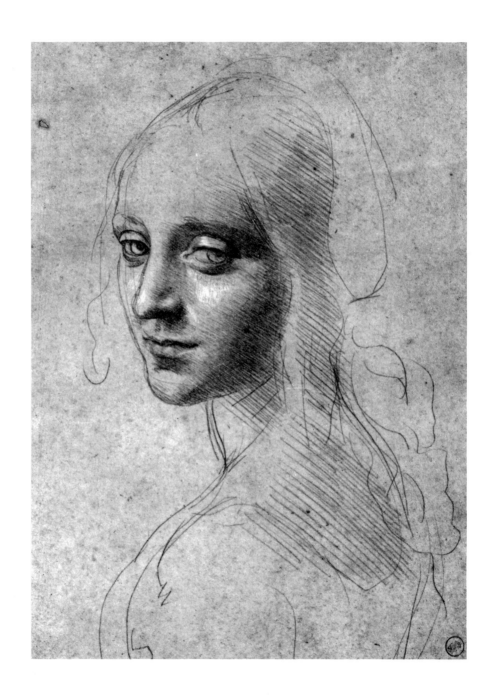

II Faces

*Stand in a museum before a portrait that looks
you full in the face. Move right, move as far left
as you like; still the portrait will follow you
with its eyes. When I was a child, I was taken
to a museum in Pannonhalma, Hungary, where
there is a picture representing the prone body
of Christ being taken down from the cross, and
I can confirm that, run about as you will, the
feet of Christ in that painting will always point
straight at you.*

*I suppose this phenomenon has been noticed
by children and nervous people for as long
as portraits have existed. It did not escape
Leonardo, who wrote in his notebook: "That
countenance which in a picture looks full in
the face of the master who made it will always
be looking at all spectators."*

*His own portraits, not only the famous "Mona
Lisa," but all the wonderful, minutely observed
sketches and drawings that remain to us, are
great treasures of art. The notes in the note-
books, with their laborious cataloging of shapes
and proportions, may seem mundane, but they* 27

Study for the head of the angel in The Madonna of the Rocks, *1483.
Biblioteca Reale, Turin.*

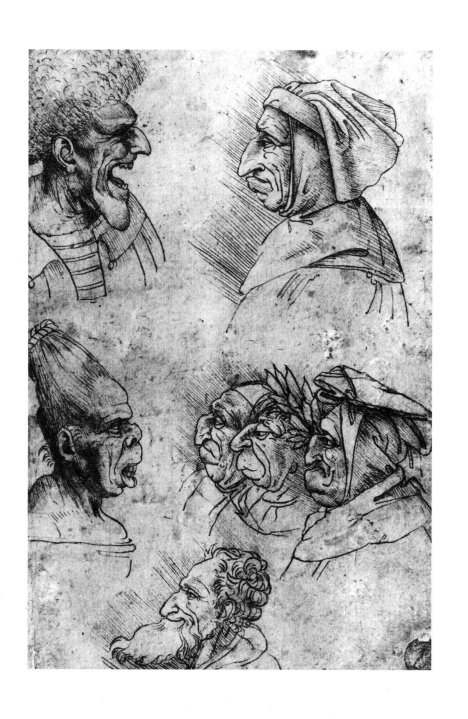

are the scaffolding behind the great beauty. Leonardo was dedicated to the correct representation of hair, cautioning his pupils never to let it be stringy or stand on end, or come out as filaments or be highlighted too greatly. He preferred hair to be painted as a mass of color, brows and beards being darker and warmer. In youthful portraits hair had to be ruffled by the wind, an effect he compared to the movement of water, and one may see it in the hair of his "Saint John" in the Louvre.

It is not well known that this master of all tender beauty was equally fascinated by ugliness. When in his wanderings about the streets of Milan he came across toothless old men or fat old women, foxy people, and thuglike soldiers, he would follow them for a whole day, admiring their ugliness, then at last rush home and draw what he remembered.

If Nature had a fixed model for the proportions of the face, everyone would look alike and it would be impossible to tell them apart; but she has varied the pattern in such a way that although there is an all but universal standard as to size, one clearly distinguishes one face from another.

If you want to remember the general forms of faces, you must start by learning how to draw several kinds of faces,

Caricatures. Accademia, Venice.

and all the parts that compose them: mouth, eyes, noses, chins, throats, necks, shoulders—in short, all the features that distinguish one man from another. These parts, with all their variations, must be drawn from Nature and then remembered. Or else, to draw a likeness from memory, you should keep a pad in which you have marked all variations of features. Then after you have had a good look at a given face, you can retire a little aside with your pad and note down the similar features, putting it all together later.

Observe and fix in your memory the variations of the four principal features of the profile: the nose, mouth, chin, and forehead. First the nose: there are three different sorts, straight, concave, and convex. Of the straight there are but four variations, short or long, high at the end or low. Of the concave type there are three sorts, some with the concavity above, some in the middle and some at the tip. The convex noses also vary in three ways, some projecting in the upper part, some in the middle and others at the bottom. Nature delights in infinite variety, and gives again three changes to those noses which project in the middle, for some are straight, some concave and some convex.

The cartilage, which raises the nose from the face, varies in eight different ways. First, it is equally straight, equally concave or equally convex. Second, it might be unequally straight, concave or convex. Third, it is straight at the upper part and concave at the lower. Fourth, straight above and convex below. Fifth, concave and straight below. Sixth, concave above and convex below. Seventh, it may be convex

in the upper part and straight in the lower. And in the eighth and last place, convex above and concave below.

The nose unites with the brows in two ways: either it is straight or concave. The forehead has three different forms: it is straight, concave, or round. The first is divided into two parts, that is, it is either convex in the upper part or in the lower, and sometimes in both; or else it is flat above and below.

Italian painters have been accused of a common fault, that is, bringing into their compositions the faces, even the whole figures, of Roman emperors which they have copied from antique art. This is an error: there should never be repetition, neither in part nor in the whole of a figure. Do not permit the same face to appear even in a different composition. And the more contrast there is between figures, that is, the deformed opposed to the beautiful, the old to the young, the strong to the feeble, the more the picture will be admired. Different characteristics, seen in contrast, will increase the beauty of the whole.

It often happens that a painter, while he is setting out his figures, will use any little sketch he has by him to serve his purpose, but this is not wise, because he will very likely find that the members he has drawn have not the motion suited to what he wants to express; after he has adapted, accurately drawn, and even all but finished them, he will hate to rub them out and start over again.

In painting a beautiful face, do not mark any of the muscles with a hard line, but let the soft light glide on them, ending

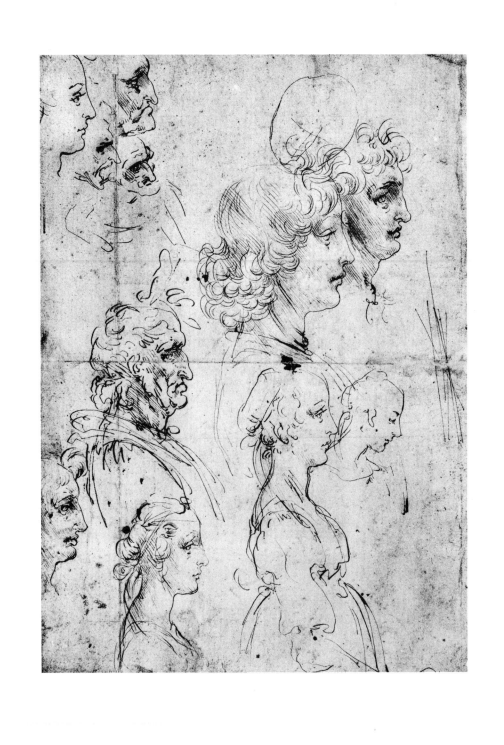

imperceptibly in delightful shadows; from this the grace and beauty of the face will arise. A face placed in a dark part of a room acquires additional grace by means of light and shadow. The shaded portion of the face blends with the darkness of the ground and the lighted part receives increased brightness, the shadows here becoming almost invisible. From this contrast of light and shadow, the face acquires relief, and beauty.

Motions of the face come about by sudden paroxysms of the mind. There are many, but the most usual ones are those caused by laughter, weeping, shouting, singing in high or low pitch, or by expressions of admiration, anger, joy, sadness, fear, pain and many others.

Laughter and weeping are very similar in the movement of mouth and cheeks, the contractions of the eyebrows and the space between them—knowledge of such changes in the face are absolutely necessary to a painter, as well as in hands, fingers and all other parts of the body, for without it his figures may as well be twice dead.

The difference between laughter and weeping lies in the crinkling of the brow, which is more elevated and extended in laughing. A weeping figure might tear his clothes or use whatever other gesture denotes the cause of his feeling: because some weep for anger, others for fear, or for tenderness, joy, suspicion; or for real pain and torment; while others weep for compassion or sorrow at the loss of a dear one. These different feelings may be expressed extravagantly or with moderation. Some only shed tears, others cry aloud, another has his face turned to Heaven with his hand de-

Studies of profiles. Royal Library, Windsor Castle.

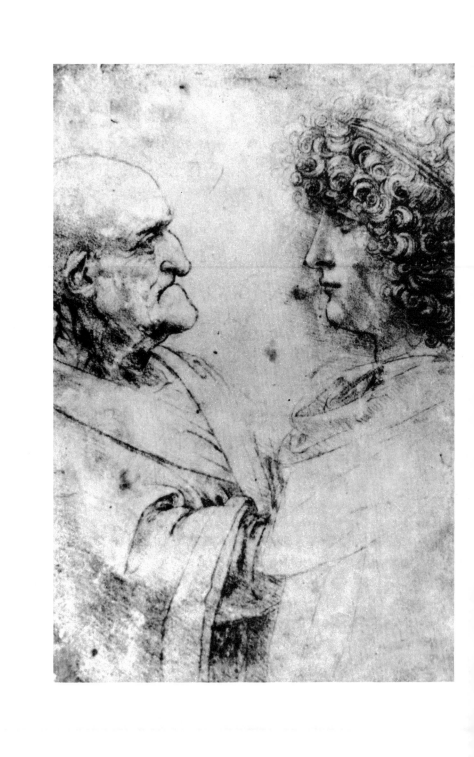

pressed, the fingers twisted. Some might be fearful and have shoulders raised to ears or some other attitude according to the cause.

Weepers raise the brows and bring them close together above the nose, forming many wrinkles, and the corners of the mouth turn down. The laughing ones turn the corners of their mouths upward and the brow is open, wide.

Take care to use the best features of faces whose beauty is established by popular agreement rather than by your own particular taste, otherwise you might end up painting over and over again faces that resemble your own—since it is a fact that such similarity pleases us. Then, if you were ugly, you would not be selecting beautiful faces but ugly ones—and that is true of many painters whose types resemble their master.

Beauty of face may be equal in different persons, but it is never similar in form. Beautiful faces should be drawn in the same great variety as the persons to whom such beauty belongs.

Watch that your faces do not have all the same expression, but give them different expressions according to age, complexion, and bad or good character.

An old man and a youth, c. 1500. Uffizi, Florence.

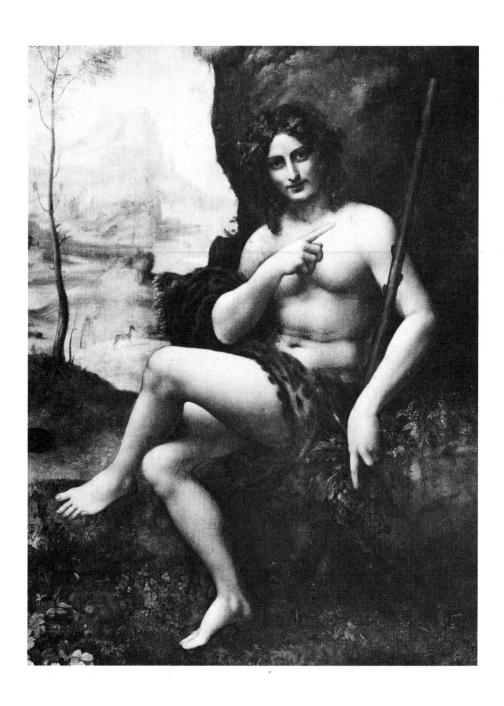

III The Body

*Aristotle, some 2,500 years ago, described the
different body builds a man can have: lean,
muscular, and fat, and he believed that each
has a corresponding temperament.*

*Leonardo did not comment on this notion,
although you can see in his paintings how well
he sensed it. He was most concerned with
showing his pupils how harmoniously the body
has been shaped to its function. A nimble and
delicate body best expresses swiftness of motion.
Fat people have tender, spongy muscles; they are
vegetative. If a man has large bones and is
muscular, he is thick and stocky.*

*The passing show of human bodies on the
street, subway, or beach is all an artist ever
needs in the way of pageantry.*

Bodily dimensions are so various in Nature that one can
never find one part of any animal that is exactly similar to
the same part in another animal of the same species. There-
fore study well the variation of forms and avoid monstrosi-

Bacchus *(detail). Louvre, Paris.*

Leonardo da Vinci's
Advice
to Artists

ties of proportion such as long legs on short bodies or narrow chests with long arms. Observe also the size of joints, since Nature is apt to vary considerably in this respect; and follow her example.

Note how the measurements of the human body vary in each member according to how it is bent, or seen from different views, increasing in one part to the degree that it diminishes in another.

In drawing from Nature, place yourself at a distance of three times the height of the object you are drawing. When you begin to draw, form in your mind a principal line, let us say, a perpendicular. Observe the relationship between the various parts of your object to that line: whether they intersect it, are parallel to it, or oblique.

In drawing a nude, sketch the whole figure and nicely fit the members to it and to each other. Even though you may only finish one portion of the drawing, just make certain that all the parts hang together, so that the study will be useful to you in the future.

All the joints of the body become larger by bending, except that of the leg.

When a figure is to appear light and nimble, the muscles should not be too marked or swollen. Such figures express action and swiftness, and their bones are never overburdened with flesh. On the contrary, they are light because they lack flesh.

38

Study of a male nude, c. 1505–08. Royal Library, Windsor Castle.

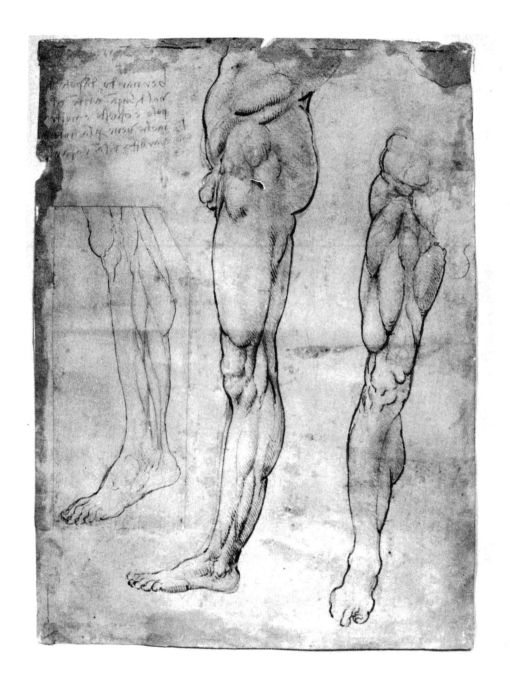

Muscular men have large bones and are in general thick and short with very little fat; because the fleshy muscles grow closer together, and the fat which would usually lodge between them has no room. And the muscles, not being able to expand, grow in thickness, particularly toward the middle.

Fat people have this in common with muscular people, that they are frequently short and thick; yet they have slender muscles. Their skin contains much spongy, soft flesh, full of air. For this reason they are lighter on the water and swim better than muscular people.

When the arm is raised or lowered, the pectoral muscles disappear or acquire greater relief. The same effect is produced by the hips, according to whether they are bent inward or outward. Note that more variety of appearance is caused by the motions of the shoulders, hips, and neck than of any other joint, because they are able to perform the greatest variety of motions.

Muscles should not be scrupulously marked all the way: this would be disagreeable to see, as well as difficult to do. But on the side where the limbs are in action, they should be more pronounced, because naturally muscles at work collect all their parts together to gain an increase of strength.

Make muscular such limbs as have to endure fatigue. Those that are not so used can be represented without muscles and soft.

Anatomical studies. Biblioteca Ambrosiana, Milan.

A man walking will always have the center of gravity directly over the center of the leg that rests on the ground.

The weight of a man resting on one leg will always be equally divided on either side of the perpendicular line of gravity.

The positions of the head and arms are infinite and I shall not enter into detailed rules concerning them. It is enough to say that they are to be easy and free, graceful and varied . . . and not appear stiff like pieces of wood.

All the members should attach to the body in motions which gracefully express the meaning the figure is intended to convey. If it is to give the idea of genteel carriage, the members should be slender and well turned, the muscles very slightly marked, softly, only as much as is necessary. The arms, particularly, should be pliant. No member should be shown in a straight line with any other adjoining member.

When a man has been standing long, the leg on which he rests gets tired, and he shifts his weight to the other. But this sort of posture is better employed for old age, or infancy, or extreme weariness. A young man, strong and healthy, will always rest upon one leg, never shifting his weight except preparatory to motion; for motion must always proceed from inequality.

The strength of limbs is more or less pronounced according to habitual exertion. Muscles will always be most prominent

in the most active members, and muscles being exerted will always be higher and larger than those at rest.

It is impossible to turn the leg inward or outward without so turning the thigh, because the setting of the bones of the knee is such that they have nothing but a backward and forward motion, and of that no more than they need to walk and kneel. If the joint of the knee had been bendable on all sides, as is that of the shoulder, or the joint of the thighs with the hip, a man would be able to bend his legs every way, and they would be seldom, if ever, straight with the thigh.

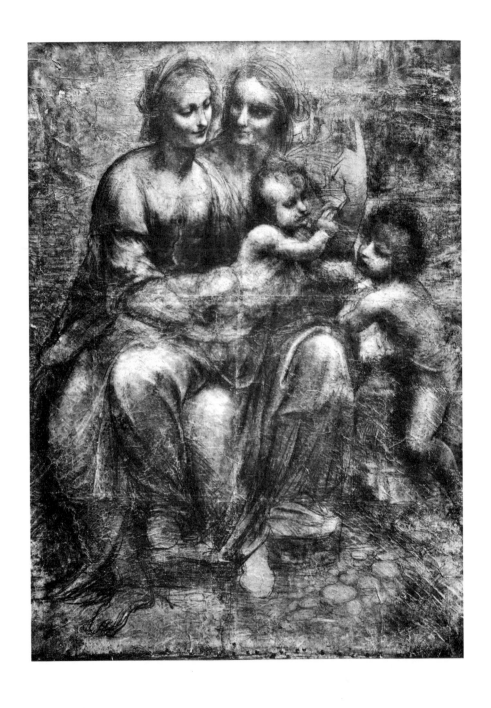

IV Children and Women

*Leonardo's concept of the child's body is seen
in the way he represents the Christ child: the
body is always fluffy; the wrists and ankles are
indicated by a fold of fat; the shanks are soft
and creased; the belly is prominent. The faces
of his children are puffy, the cheeks blown up,
the lower lips sucked in, and the expression in
the eyes is mild. Such characteristics tell us of
Leonardo's own soft, very sensitive, tender
nature.*

*The most famous painting in the world is his
"Mona Lisa," and yet he is said never to have
loved a woman. The famous smile at the corners
of the lips might, indeed, have been produced
by the musicians and acrobats who were called
in to entertain the painter and his model, but
on the other hand, you will see the same
supernal tenderness expressed in the lips of
his Virgin Mary and Saint Anne, or on the face
of a gentlewoman in the Uffizi Gallery. Perhaps
Leonardo was painting over and over again the
mother he may have lost when he was taken
away from Caterina.*

45

Cartoon for The Madonna with St. Anne, *c. 1500. National Gallery, London.*

Leonardo da Vinci's
Advice
to Artists

The "Mona Lisa" is one of his great "unfinished" works. He painted on it for four years on and off, and when he went to live in France, he took the painting with him to work on it some more. He died dissatisfied with it. The picture is today in the Louvre in Paris.

There is a great difference between adults and children in the joints and in the length of the bones. A man has the length of two heads from the outer edge of one shoulder to the other; the same from shoulder to elbow and from the elbow to the fingers. But a child has the length of only one head, because Nature gives a proper size first to the seat of the intellect, and afterward to the other parts.

The breadth of a child's shoulders is equal to the length of the face, or to the length of the arm from shoulder to elbow when the arm is bent; and it is the same for the distance between the lower belly and knee, or knee and foot. But in the adult, every one of these lengths is doubled except that of the face, which, with the top of the head, undergoes but little alteration. A well-proportioned, full-grown man, therefore, is ten times the length of his face; the breadth of his shoulders will be two faces; and so on—all the lengths will be doubled.

Young children have small joints, but the spaces between joints are thick and plump. There is nothing on the bones at

46

Studies of children, c. 1500. Musée Condé, Chantilly.

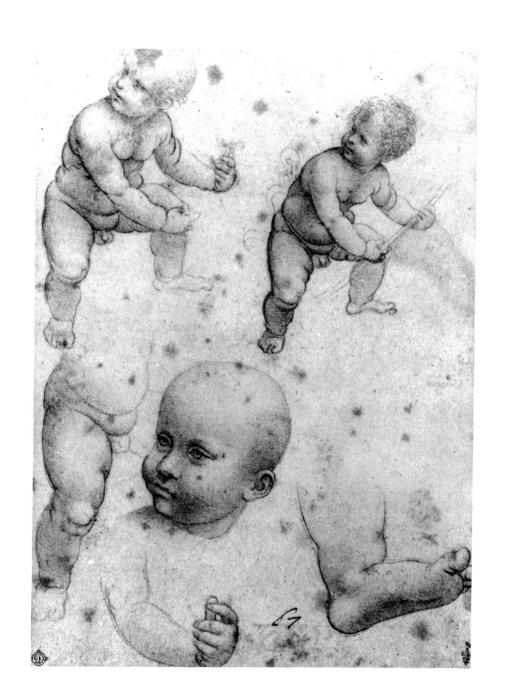

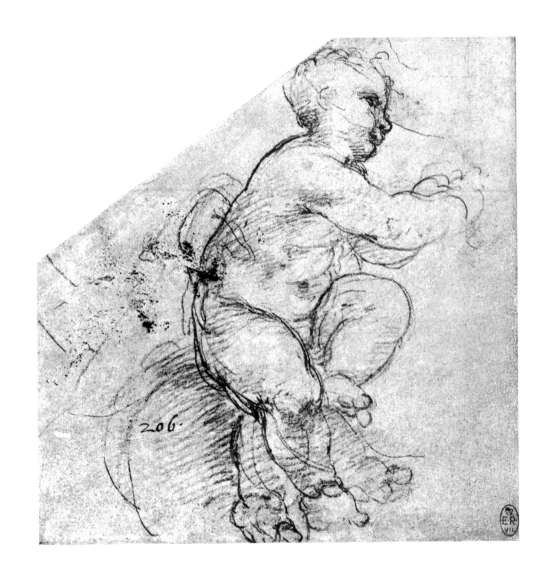

the joints besides the tendons which bind the bones to-
gether. The spaces in between, however, have soft flesh, full
of fluids which are enclosed under the skin. In the progress
to manhood, the superfluity is thrown off and the skin
shrinks nearer the bones, thinning down everything. But the
skin of the joints does not lessen, as there is nothing but
cartilage and tendons underneath it. So, while children are
small at the joints and plump between, as you can see in
their fingers, arms, and narrow shoulders, men on the other
hand are filled out at the joints; and where children have
hollows, men have knots.

The best painting is that which is most like its subject. This
statement will certainly fill certain painters with confusion,
the kind that likes to improve on the works of Nature; for
instance, when they draw a child twelve months old, making
him eight heads tall, when Nature, doing her best, permits
only five. The breadth of the shoulders also, which is equal
to the head, is doubled, giving a year-old child the pro-
portions of a man of thirty.

So often have they practiced and seen others practice these
errors, so that error becomes habit, deep-rooted in their cor-
rupt judgment; and they are persuaded that Nature and her
imitators must be wrong for not following their example.

Little children, sitting, should be shown twisting themselves
about with quick movement. Standing up, they have shy,
timid attitudes.

It is not becoming in women and young people to be shown

Study of a child. Royal Library, Windsor Castle.

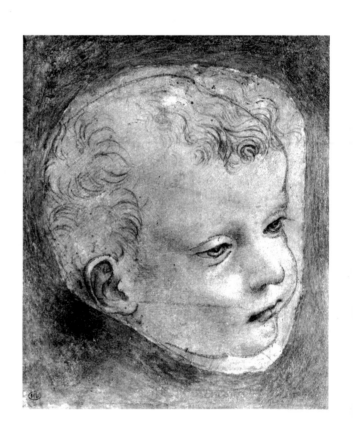

Above: Child's head. Louvre, Paris.

Opposite: Attributed to Leonardo: Profile of a young woman, c. 1475.
Uffizi, Florence.

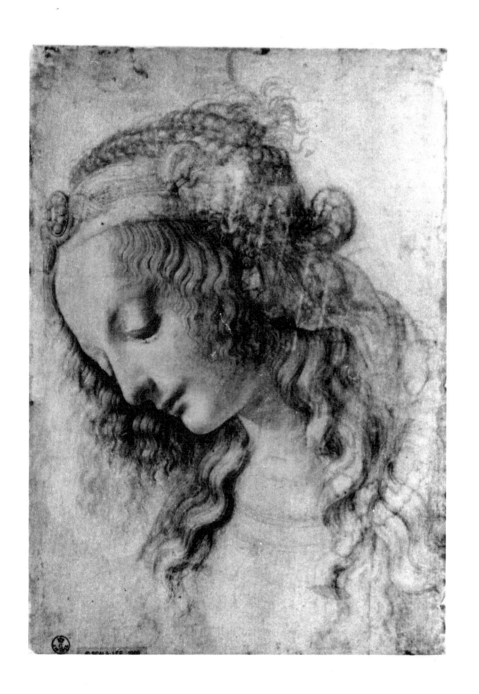

with their legs too far apart, because this has an air of boldness, while legs close together show modesty.

Old women should be shown as bold, with swift, passionate movements . . . and these movements should seem quicker in the head and arms than in the legs.

Let the members of living creatures fit their physical type. Don't attach a thin leg or arm or other limb to a figure with a thick chest or neck. And do not mix the limbs of the young with those of the aged, nor vigorous and muscular limbs with delicate fine ones; nor those of males with those of females.

V Anatomy

*Once when I was an art student in Munich, I
complained to a waitress that my chicken was
nothing but bones. She snapped, "Chickens
must have bones; they can't walk on sausages."
As it turned out, I treasured this lesson in
anatomy longer than much that my art teacher
said.*

*In drawing the human body, or any body, one
must know thoroughly what is underneath the
skin, for that is what shapes the surface and
changes the surface by its action. Leonardo was
the first to make accurate drawings of the curves
of the spine and the tilt of the sacrum. He
described the rounding and sloping of the ribs,
which is essential to understanding how people
breathe, and he was the first to recognize the
function of the pelvis as one of the unrepealable
laws of the upright skeleton. In his drawing of
the skull, he showed the configuration of
the bones and drew the lachrymal canal,
commenting, most unanatomically, "Tears rise
into the eyes from the heart."*

In sum, his advice to young students of anatomy is, "Begin your study at the head and finish with the feet."

The most important thing in drawing figures is to set the head well on the shoulders, the chest on the hips, and the hips and shoulders on the feet.

Study anatomy as a science: then follow the practices that reflect the science. Be methodical and do not quit one part until it is perfectly engraved on your memory.

It is extremely necessary for painters to know the bones that support the flesh, particularly the joints whose motion appears to diminish or increase the length of members: for example, the arm does not measure the same when bent as when extended, there being a difference of about one eighth of its length. This increase and diminution of the arm is caused by the bone projecting out of its socket at the elbow.

When the joints bend, the flesh always forms a crease on the opposite side from that which is tight.

The joints of the fingers appear larger when they bend, and the more they bend, the larger they appear; the same with the toes, and this will be more perceptible in proportion to their fleshiness.

55

Anatomical drawings of a man's neck and shoulders, 1500. Royal Library, Windsor Castle.

The muscles of young men should not be strongly marked or greatly swelled, because this would indicate an age of full strength and vigor which they have not yet attained. Nevertheless, the muscles are expressed more or less, in the degree that they are employed. Those in motion are always more swelled and thicker than those which remain at rest.

The muscle at the back of the thigh shows more variety in extension and contraction than any other in the body. Next to it in this respect are those composing the buttocks; third, the muscles of the back; fourth, those of the neck; fifth, those of the shoulders; and sixth, the muscles of the abdomen, which, rising under the breast, terminate under the lower belly.

In the joints of the body, there are certain small bones, fixed in the middle of the tendons: such are the patellas of the knees, the joints of the shoulders, and those of the feet. There are eight of them, one at each shoulder, one at each knee, and two at each foot under the first joint of the great toe, toward the heel. These grow extremely hard as a man advances in years.

Take notes on which muscles and tendons are brought into play by action, and when they remain hidden: such observations are important to painters and sculptors professing a knowledge of anatomy and the science of the muscles. Likewise describe children, following the different gradations of growth from birth to old age, noting the changes which

Musculature of the trunk. Royal Library, Windsor Castle.

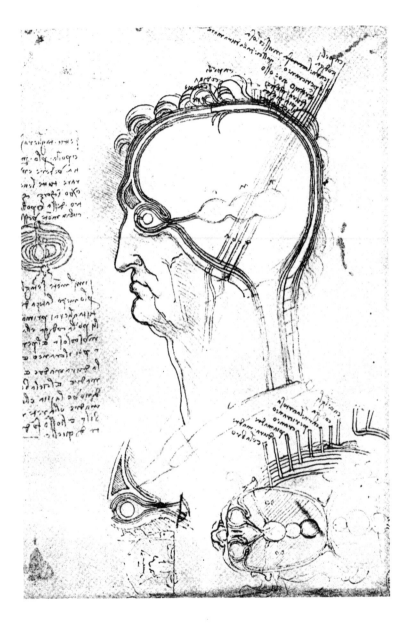

The central nervous system and the cranial nerves, c. 1500. Royal Library, Windsor Castle.

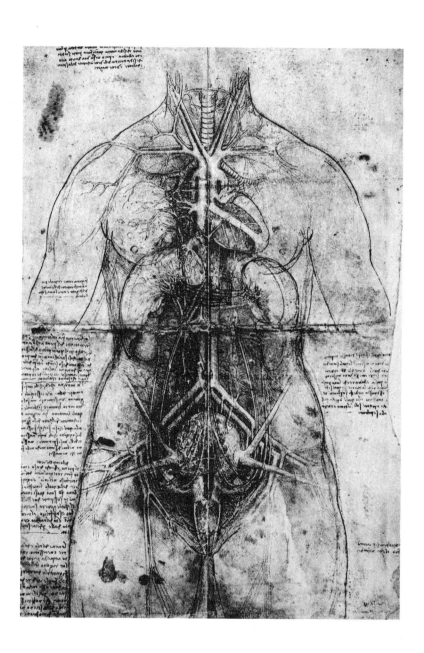

Anatomical study. Royal Library, Windsor Castle.

the members, particularly the joints, undergo; which of them grow fat, and which lean.

The painter who acquires a perfect knowledge of the nature of the tendons and muscles, and of those parts which contain most of them, will know exactly how to depict a particular motion of any part of the body, and what muscles give rise and contribute to it. . . .

He will not imitate those who, no matter what attitude they represent, or invent, make use of the same muscles in the arms, back, chest, or any other part.

Where the arm is joined to the hand, there is a ligament, the largest in the human body, which has no muscles, and is said to be the strongest ligament of the body. It is square, and it serves to bind close together the bones of the arm and the tendons of the fingers.

A naked figure, strongly marked so as to give a distinct view of all muscles, cannot be in motion; because the instant it moved, some of the muscles would relax while the others pulled, and those which relaxed would cease to appear in the same proportion as the others, pulling strongly, would become more marked.

A man is more powerful in pulling than in pushing, for when he pulls, the united exertion of all the muscles of the arm is called into play, while in pushing, some of them remain inactive.

The body which bends lengthens as much on one side as it shortens on the other; but the central line between them will never lessen or increase.

VI Man in Motion

*One can only conjecture about the number of
hours Leonardo must have spent observing
other men and the number of notebooks he
must have filled before he collected his thoughts
on motion. The following are but a small
sample of them, but they show very well how
his scientific and scholastic knowledge acted
upon his visual experience.*

*Today, very likely, Leonardo would suggest
watching the action of basketball players,
gymnasts, boxers, and soccer players; as a
matter of fact, he did recommend watching the
players of his time. Each sport, depending on
the rules of the game, has characteristic
movements associated with it. A soccer player,
who is not permitted to touch the ball with his
hands, will make altogether different movements
from a basketball player, whose hands are his
weapons, and each will have built up a different
set of muscles.*

*I cannot imagine how Leonardo knew that
when a man jumps, his head moves three times*

Six studies of figures. Louvre, Paris.

faster than his heel and twice as fast as his hips.
He saw it, I suppose.

After you have learned well your rules of perspective and of the anatomy of the human body and forms of objects, you should make a point of walking about watching people in action; for example, when they are talking or quarreling; or when they laugh or fight. Watch their positions, and those of the spectators, whether they are attempting to separate the fighters or merely looking on. Sketch quickly with light strokes on your pad (which you should always have with you), and when it is full, start another, never rubbing out but keeping all carefully, because the forms and motions of bodies are so infinitely various that they cannot possibly be retained in the memory. Therefore preserve your sketches, for they are your assistants and your masters.

The eighteen actions of man are: resting, moving, moving swiftly, standing erect, leaning, sitting, bending, kneeling, lying down, hanging, carrying, being carried, pushing, dragging, striking, being struck, pressing down, and raising up.

Motion is nonexistent in any animal which rests upon all its feet, because in this case the weight is equally distributed on each side of the line of gravity.

Motion occurs when there is a loss of equipoise, that is, equal distribution of weight. For nothing can move without

losing its center of gravity, and the farther it is removed, the quicker and stronger will be the motion.

The first thing you need if you want to grasp the motions of the human body is a knowledge of all the parts, particularly the joints, in every possible attitude that they might assume.

Equipoise of the parts of the human body may be simple or complex. If a man stands equally upon both feet, the middle of his chest will be perpendicular to the middle of the line which measures the space between the centers of his feet. If, with a simple motion, he extends each of his arms at a different distance from center, or stoops, then the center of his weight will always be perpendicular to the center of the foot supporting the body.

A complex balance is when a man carries a weight that is not his own, bearing it with different motions, as for example Hercules stifling Antaeus by pressing him against his breast after lifting him from the ground. He must have exactly that much weight thrown back upon the central line of his feet as Antaeus adds to his front.

If the motion of the figure calls for the right hip to be higher than the left, make the shoulder joint perpendicular to the highest part of that hip, and drop the right shoulder lower than the left. The pit of the neck will always be perpendicular to the middle of the instep of the foot that supports the body. The leg that does not bear the weight of the body

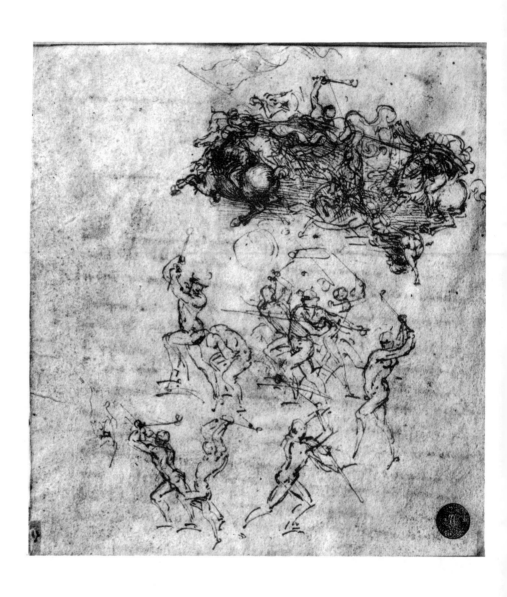

Battle of horsemen and of foot soldiers, c. 1503–04. Accademia, Venice.

will have its knee a little lower than the other and it will be close to the other leg.

A single figure, running, cannot throw both hands forward; it throws one forward and the other back, otherwise it could not run. If the right foot comes forward, the right arm must go backward, and the left arm forward. If another figure is drawn to follow this, one of its legs should be brought somewhat forward and the other made perpendicular under the head. The arm on that side comes forward.

A figure should have harmonious contrast of its parts. If one arm comes forward, the other should be still or remain behind. If the figure rests on one leg, the shoulder on that side would be lower than the other, because the leg which does not support the weight any more than if it were dead would be bent; therefore all the parts above it must transfer their center of gravity to the leg which supports the body.
 Artists of judgment are careful to balance their figures properly lest they appear to be about to fall.

A person driving a pole into the ground, or drawing one out of it, will raise the leg and bend the knee opposite to the arm which is exerting strength, so that the weight is balanced on the foot that rests. Without this motion no one would ever drive a pole in or pull it out of anything.

A weight cannot be lifted or carried by any man unless he gathers more than an equal weight of his own to throw on the opposite side.

67

Leonardo da Vinci's
Advice
to Artists

When a man throws a dart or a stone or any other thing, he may be represented in two different ways: he may be preparing to do it, or he has done it.

When men work hard with specific motions, the muscles will show more strongly on the side brought hardest into action. The other muscles will be more or less marked, according to the degree that they participate in the same motion.

When a man jumps upward the motion of the head is three times quicker than that of the heel before the toe quits the ground and twice as quick as the motion of the hips.

When a man is about to jump, Nature of itself, without any reasoning in the mind of the man, prompts him to raise his arms and shoulders and, with a sudden motion, lift them up high together with a great part of the body, until the power generated by the effort subsides. This motion is accompanied by an instantaneous extension of the body, which had been bent like a spring or a bow along the back and the joints of the thighs, knees, and feet, and it is let off obliquely upward and forward, so that in so springing up the body describes a great arc, thus increasing the leap.

Complex motion is that which requires the body, in producing a particular action, to bend downward and sideways at the same time. The artist should be careful to use these complex motions appropriately, and not weaken or destroy

68

Figure studies. British Museum, London.

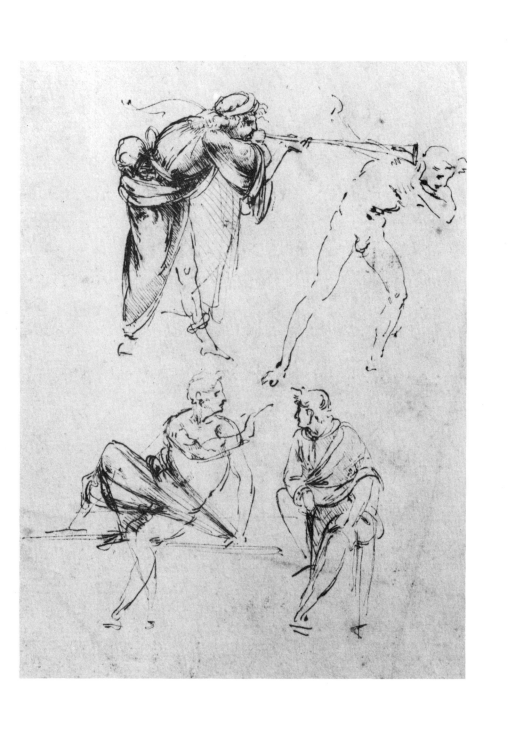

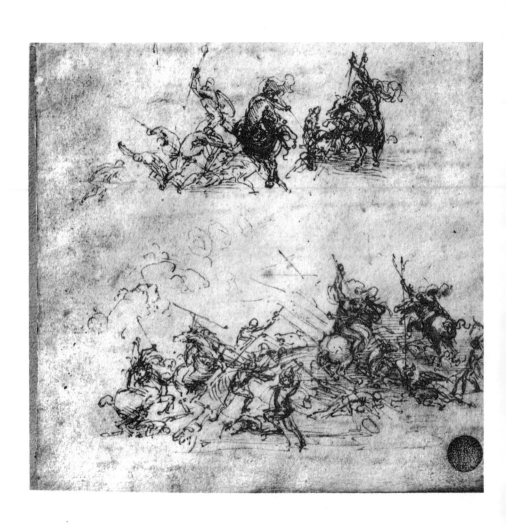

Two groups of horsemen fighting, c. 1503–04. Accademia, Venice.

the effect by introducing other figures with simple motions having no connection with the subject of the painting.

When a man prepares himself to strike a violent blow, he bends and twists his body as far as he can to the side contrary to that from which he means to strike, and then, collecting all his strength, with a complex motion he comes back and attacks the focus of his violence.

The utmost twist that can be accomplished by the body is when the back of the heels and the front of the face can be seen at the same time. This is a difficult motion and it is done by bending the leg and lowering the shoulder on the side toward which the head turns.

A foot bearing the weight of the whole body should not be playing its toes up and down; they should lie flat on the ground—except in those cases where the weight is resting entirely upon the heel.

A man never ascends or descends, or walks at all in any direction, without raising the heel.

It is particularly useful to observe the variety produced by the shape of joints when they bend: how the muscles swell on one side while flattening on the other; and this is especially apparent in the neck.

Neck motions are of three sorts, two simple and the other complex, combining the other two.

The simple motions are: first, the neck bending toward

the shoulder right or left, back or front, thus raising or lowering the head; the second, twisting to the right or left without raising or lowering, but remaining straight with the head turned toward one of the shoulders. The third motion, which is called complex, is added to twisting, as when an ear leans toward one of the shoulders, the head turning the same way and the face turning upward.

A shoulder bearing a weight is always higher than the other. . . . If the weight were not equally divided on each side of this central line of gravity, the whole would topple. But Nature has provided that as much of the natural weight of a man can be thrown on one side as he may take up on the other, thus creating counterpoise. We observe that when a man lifts a weight with one arm he naturally throws out the opposite arm; and if this motion of the arm is not enough to form a counterpoise, then by bending his body he will add as much as necessary of his own weight as will enable him to resist the load.

The principal motions of the shoulder are simple ones: they move the arm up and down, back and forth. And yet, this simple motion might almost be called infinite, for if that arm should trace a circle upon the wall, it will have performed all the motions of which the shoulder is capable.

Positions of head and arms are numberless; I cannot give a rule. I shall have said enough if I say that all motion should seem natural, should bend and turn in a way that joints move freely, not as if they were pieces of wood.

72

Man in a life preserver. Bibliothèque de l'Institut, Paris.

An action by which a figure points at anything near should show the hand very little removed from the body. If the object is far distant, the hand should be far removed from the body and the face of the figure turn toward those to whom he is pointing it out.

All motions should express the degree of strength needed by the action. The same effort is not used to pick up a stick as to raise a piece of timber. Show variety in the expression of strength.

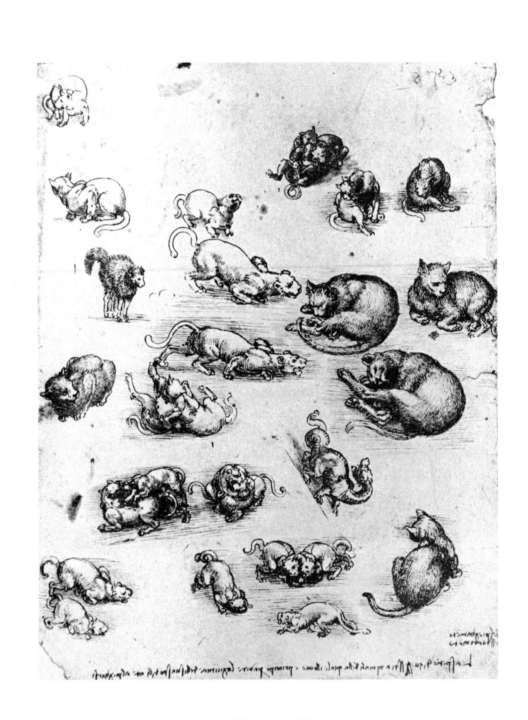

VII Animals

It was important for painters in Leonardo's day to know how to draw animals, because they formed the devices of the coats of arms which were being designed to mark the identity of noble families. When a real animal was not good enough, the artist could turn to the monsters of mythology.

Leonardo had a fancy for monsters. As a boy he had collected lizards, hedgehogs, newts, snakes, and all sorts of strange creatures. When his father asked him to design a coat of arms, Leonardo made up a monster and actually constructed it—a hideous creature, for which he used the heads of defunct specimens. He then asked his father to come and see it. The room was dim, and Ser Piero had forgotten about the commission. When the monster fairly leaped at him from the shadows, he almost fainted.

Later, without telling his son, Ser Piero sold the design for the coat of arms for ten ducats to a Florentine art dealer, who passed it on to the Duke of Milan for three hundred ducats. All

75

Studies of cats and of a dragon. Royal Library, Windsor Castle.

Leonardo got out of it was the right to consider himself an expert on monsters.

Real or imaginary, the animal kingdom did not escape Leonardo's minute scientific attention, and in all his researches, observations, and dissections, his aim was to demonstrate the universal connection of form and function.

Man, he said, is in reality a quadruped, who "in infancy crawls on all fours and when grown moves his limbs crosswise like a horse trotting; that is, when he puts his right foot forward, his left arm goes forward too, and vice versa, invariably."

He dissected the body of a lion and found that the "king of the beasts," as he called it, was furnished with much keener senses than man: the eye sockets occupied a comparatively large part of the head, and the optic nerves, which in man are thin, long, and weak, were intimately bound up with the brain. The organ of smell also had a lot of house room in the animal's skull.

Leonardo also dissected a bear and an ape, because he wanted to know "just how different is the foot of a bear or an ape from that of a man."

These ideas of universality inspired Leonardo's researches some 350 years before similar notions came to roost in the head of Charles Darwin.

In painting an imaginary animal, obviously it will be impossible to invent one without the usual parts of animals, and these, individually, should resemble those of known animals. If you wish, therefore, to draw a natural-looking chimera or other imaginary beast, let us say a mythological serpent, you might take the head of a mastiff, the eyes of a cat, the ears of a porcupine, the mouth of a hare, the brows of a lion, the temples of an old rooster, the neck of a sea-tortoise, and put them all together.

Compare the legs of a frog with those of man: they have great resemblance, both in bone and muscle. Observe the hind legs of a hare, how muscular they are, strong and active, because they are not encumbered with fat.

All land animals resemble each other in limbs, sinews, and bones, and they do not vary at all except in length and thickness. Of aquatic animals there are so many different kinds that I cannot advise a standard: they are of the most infinite variety. The same is true of insects.

When a biped moves, the part of the body immediately above the foot that is raised is lower than the part above the foot that rests on the ground. You can see this on the hips and shoulders of a man when he walks; and also in walking birds, the motion of head and rump.

In the case of quadrupeds, more variation can be seen in the higher parts of the body when they walk than when they are still, more or less, according to size. This proceeds from the oblique position of the legs touching the ground and

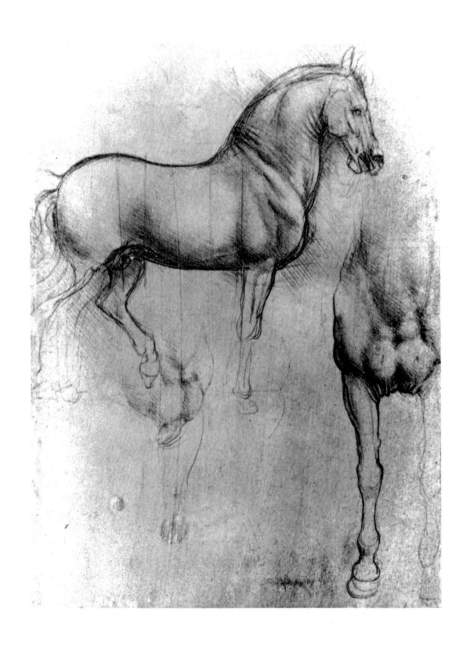

Profile and forelegs of a horse, c. 1488. Royal Library, Windsor Castle.

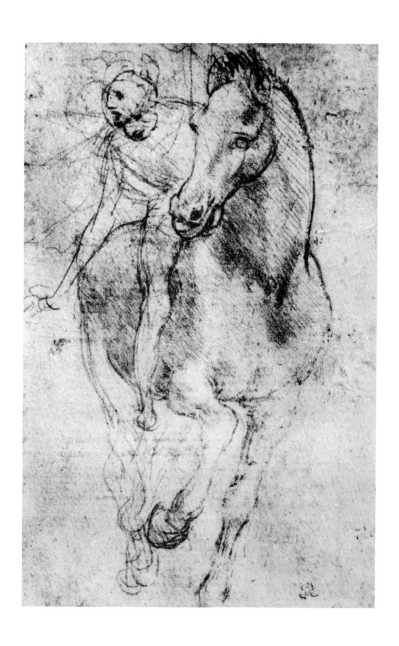

Horse with rider. Collection of Mr. John Nichols Brown, Newport, Rhode Island.

then raising the animal as they assume a straight and perpendicular position.

The motion of a man walking—or any other animal—will be quicker or slower as the center of gravity is more or less removed from the center of the supporting foot.

That figure will appear swifter the more it leans forward. Any moving figure looks speedier the farther the center of gravity is removed from the center of its support. This is seen well in the motion of birds which, without any flapping of wings or assistance from the wind, move themselves. This occurs when the center of gravity moves out of its usual residence, that is, at the middle point, between the wings.

81

Above: Apparatus for determining the center of gravity of a bird.

Opposite: A bird's wing and the action of tendons in flight.

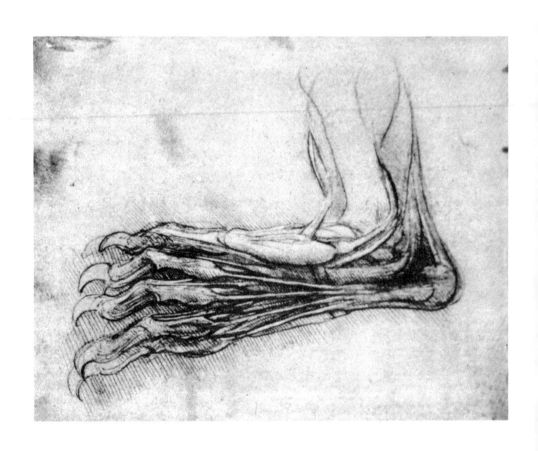

Dissection of the hind foot of a bear, c. 1490–93. Royal Library, Windsor Castle.

The limbs of every kind of animal correspond with the animal's age: that is, young animals should not be shown having a lot of veins or nerves as they very often are by painters who want to show how clever they are, but spoil everything by such mistakes.

All parts of the animal correspond with the whole. A short and thickset animal has short and thickset limbs.

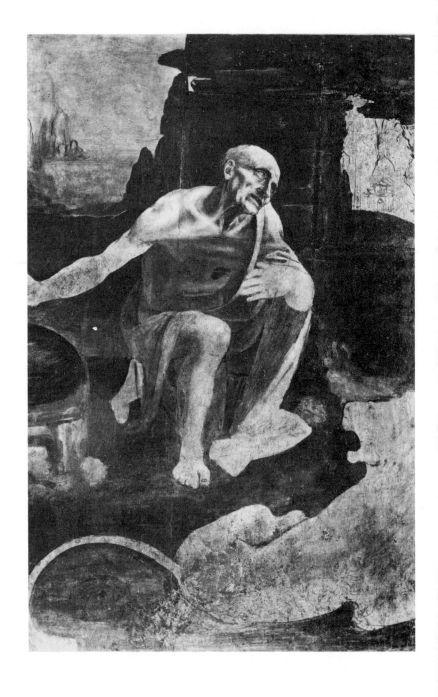

VIII Motions and Emotions

*An emotion, a state of mind, always finds
expression in a person's face and body. When
a man is angry, he shows his teeth and frowns;
his eyes seem to shoot darts; he tightens his
facial muscles and his whole posture, stiffening
his neck and balling his fists. A man who is
afraid turns pale, obliquely raises his brows, and
bulges his eyes; he stands motionless with his
neck pulled in, his knees bent and trembling.*

*Such emotions may be temporary or habitual.
An habitual emotion imprints itself on a
person's face and body like an inscription in
bronze; it becomes "character."*

*Artistically, it is by no means easy to represent
the emotions on one's face or body; in any
civilization emotion in art does not become
credible until after a stage of sophistication has
been reached. One of the symptoms by which
we may discern that we are not living in a
period of great artistic flowering, in spite of all
the paint being splashed about, is that
in general our portraiture is flat and
expressionless. Rarely does one see memorable*

St. Jerome, *c. 1481. Vatican, Rome.*

Leonardo da Vinci's
Advice
to Artists

"character" in today's paintings, such as that in a Goya painting. I do not mean I have never seen a modern portrait that moves me, only that it is I, faced with mystery, who must supply the meaning.

Leonardo did not indulge in mysteries. He believed the artist should do the thinking and make a statement. Even his "Mona Lisa," a so-called mystery, is a statement.

Figures should move in a way appropriate to what they are supposed to be thinking or saying. You may learn such motions well by watching the deaf and dumb, who, by movements of hand, eyes and eyebrows, and indeed the whole body, try to make their thoughts clear. Don't laugh at the notion of a master without a tongue teaching you an art he does not understand: he will teach you better by his expressive motions than will all the rest by word and example.

Figures should seem to know what they are about, moving with spirit or showing whatever degree of emotion is proper to the subject. Slow and tardy motions are just as expressive as those of eagerness, while the fierce ones are portrayed with such force that one actually feels the sensation.

A figure that does not make lifelike gestures can be said to be twice dead: the first time because the painting itself is

The Adoration of the Magi *(detail), 1481–82. Uffizi, Florence.*

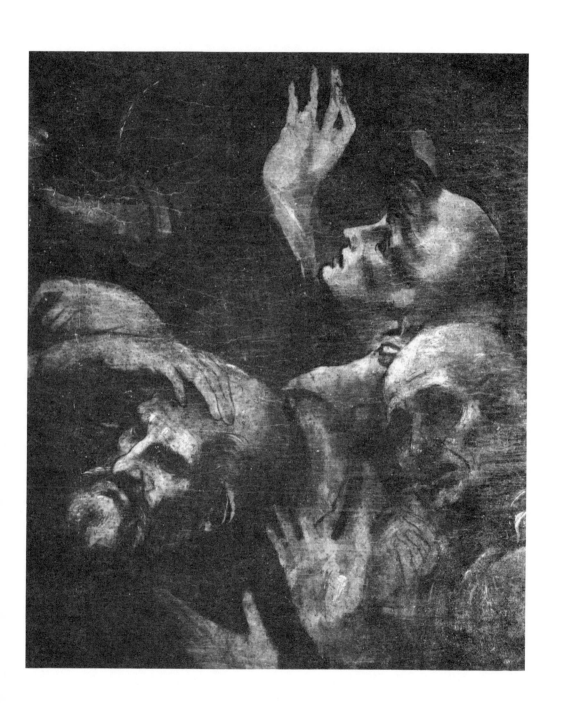

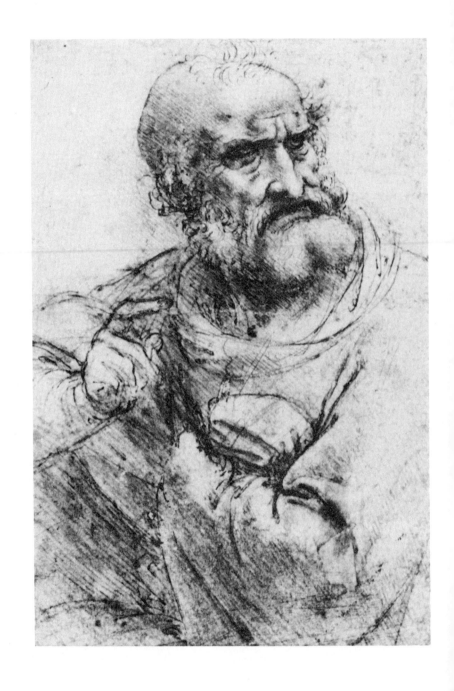

not alive, only simulating living things but having no life in itself, so that if you do not add liveliness of action, it is dead for the second time.

Therefore study people who gesticulate when they talk. . . . If you can, get close enough to hear what is causing them to make a particular gesture. Consider those who laugh and those who cry, watch those screaming in anger; by this means learn how we express what is happening in our minds.

Note what motions are proper to what sort of people. Do not make a master act like a slave or a child like an adolescent or an old man who can hardly stand. Do not give a peasant a gesture more appropriate to a nobleman. Do not let the strong act like the weak, or let a prostitute move like an honest woman, nor give men the motion of women.

Make light sketches as the opportunity occurs of people's actions the moment they meet your eye. Take care you are not seen; because if you are seen, the model is disturbed in his freedom of action, which should reflect his inward feeling.

Suppose two men are quarreling, angry, each of them thinking himself in the right and both vehemently moving their eyebrows, arms, all the members and every motion appropriate to word and feeling. They could not possibly do this if you wanted them to imitate anger, or any other accidental emotion—laughter, pain, admiration, fear, anything.

For this reason take care: never be without your little pad.

Watch the quick motions men make without thinking, espe-

89

Half-length of an apostle (St. Peter?); study for The Last Supper, *1495–97.
Albertina, Vienna.*

cially under the influence of some strong frame of mind. Take note of them, sketch them in your pad, so that you have them there when needed. Then, you can put a living model in the same position to see the pattern of muscles in action.

A figure is not well done unless action appears in it that expresses a state of mind. The figure that best expresses, by action, the passions that animate it is the one best worthy of praise.

In a painting, all those present at a certain event express their attitude in various ways. If the subject is one of devotion, as at the elevation of the Host at Mass or some such ceremony, the eyes of all present should be directed toward the object of adoration, with accompanying pious gestures. A laughable subject, or one evoking compassion, would not call for all to have their eyes turned toward the object, but they will express their feelings by different actions; and let several figures be assembled in groups to laugh or cry together. If the event is terrifying, the faces of those fleeing the sight would be strongly expressive of fright, and the gestures would be appropriate.

When showing a man in the act of speaking to a large assembly of people, consider the subject of his discourse, and adapt his attitude to it. If he is wanting to be persuasive, let this show in his gesture. If he is explaining something, giving his several reasons, let him put two fingers of the right hand on one of the left—the other fingers being tightly curled—and turn his face toward the audience with the

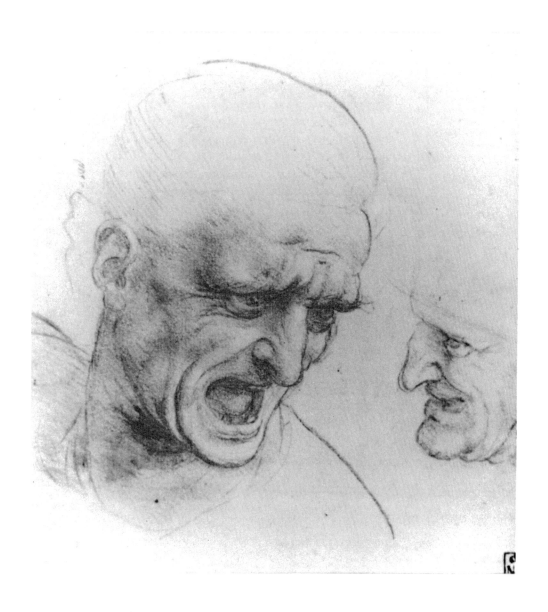

Study for two heads in The Battle of Anghiari, *1503–04.*
Szépmüvészeti Muzeum, Budapest.

mouth half open, seeming to speak. If he is sitting, let him appear as if he is about to raise himself a little, his head coming forward; and if standing, let him bend his chest and his head toward the people.

The audience should appear silent and attentive, their eyes upon the speaker. Some old men have their lips pursed approvingly, causing wrinkles to appear at the corners of the mouth and on the cheeks, and more wrinkles will form on the forehead, caused by the eyebrows raised in an expression of astonishment. Others of the seated ones might have their hands clasped around one knee; some have one knee on the other, and on that a hand cupping the elbow while the other supports the chin which is covered by a venerable beard.

The last act of despair is when a man is about to put an end to his life. He is shown with a knife in one hand with which he has already stabbed himself and he clutches the wound with the other. His dress and hair are torn. He stands with his feet apart, his knees a little bent, his body leaning forward as if to topple.

If you want to show a man in a state of violent anger, make him seize his antagonist by the hair and hold his head twisted down against the ground with his knee dug into the ribs; his right arm up and his fist set to strike; his hair on end, his eyebrows low and straight; his teeth clenched and visible at the corners of the mouth; his neck swollen and his body creased at the abdomen because he is bending over his enemy in an excess of passion.

There are some emotions that are not expressed by any particular motion of the body; while some cannot be expressed without it. In the first, the arms fall down and the hands and all other parts which are ordinarily active remain quiescent.

In a dead body, or one asleep, no member should appear alive or awake.

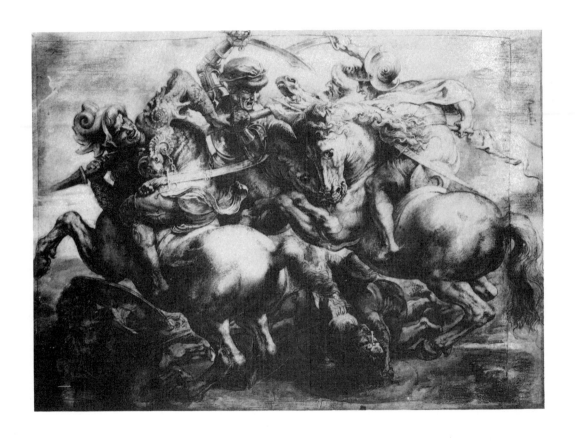

Peter Paul Rubens: after Leonardo, The Fight for the Standard, *c. 1605.*
Louvre, Paris.

IX Painting
Historical Compositions

Leonardo's time was one of summing up. People —the nobles, that is—wanted to establish their position of honor, and they looked back for great events to confirm that position. Leonardo, if only he had been able to stick to a painting, could have made his fortune in this aspect of art alone, but as usual he preferred to think rather than to do.

One can only guess whether his visions of mighty science-fiction machines, such as the submarine, the machine gun, or the airplane, arose from his dramatic view of battle scenes, or if the inventions evoked the view. A battle, he wrote, should be shown taking place in clouds of dust glowing under a distant light, and it should be a swirl of frenzied horses and fleeing men, a scene of horror and wild yells, with victims whose eyes are misted with death, "and do not leave any level spot that is not trampled and soaked with blood."

He was commissioned by the Signora of Florence to paint such a fresco, commemorating the Florentines' victory over the Milanese in

Leonardo da Vinci's
Advice
to Artists

1440. She gave him a considerable amount of money in advance for the work, and he dutifully began to make sketches of galloping horses with distended nostrils biting one another's necks and of many wild-eyed, bullnecked men, who were to be the models for bloodthirsty soldiers. He got the Signora to build a special scaffold— sort of a flying bridge—and he began the actual work, using his own paint, which was specially invented, and setting up braziers to dry it. But the color melted and ran down the walls, and finally, the oil and turpentine went up in flames.

Leonardo fled with the advance and all, and the Signora sued him. By that time, however, he had found a protector in the French king, who advised the Signora that since she was dealing with a genius, she had better forget about her money.

The sketches Leonardo made for this work might have gone up in the smoke of time too except that, some time later, a young Flemish artist, Peter Paul Rubens, who was traveling in Florence, copied them in chalk.

In painting historical compositions, the artist should strive to bring the greatest possible variety to the scene, presenting figures differing in temper, size, complexion, action, plump-ness, leanness, roughness, smoothness, age, youth, strength,

weakness, cheerfulness and melancholy. Some should wear their hair curled, others have it straight, or short, or long. Some will be quick in motion, others slow, and all will wear a variety of dress and color, according to the subject.

By such fertility of invention is the eye of the beholder charmed. Whatsoever mixture the subject permits should be portrayed: men differing in face, age, dress, grouped with women, children, dogs and horses, and all shown against buildings, flat country, high country.

In historical subjects, two things are important: the first is the exact outline and shape of figures. The second is the exact expression of what is going on in the minds of the figures. This is very important.

A figure which does not express in its posture the feelings that are supposed to animate it will look as if its body cannot obey its mind. A figure should always be assertive, and have the appropriate gesture, so that the meaning cannot be mistaken for any other.

The student should begin his composition by lightly sketching some single figure, trying it out from all angles, knowing well how to extend or contract the various members, as needed. Then he may put two figures together in various attitudes, let us say fighting; this too should be tried out from all sides.

Then let him imagine that one of the figures is very courageous and the other not so. All such accidental mind-effects should be observed with great care and studied, dwelt

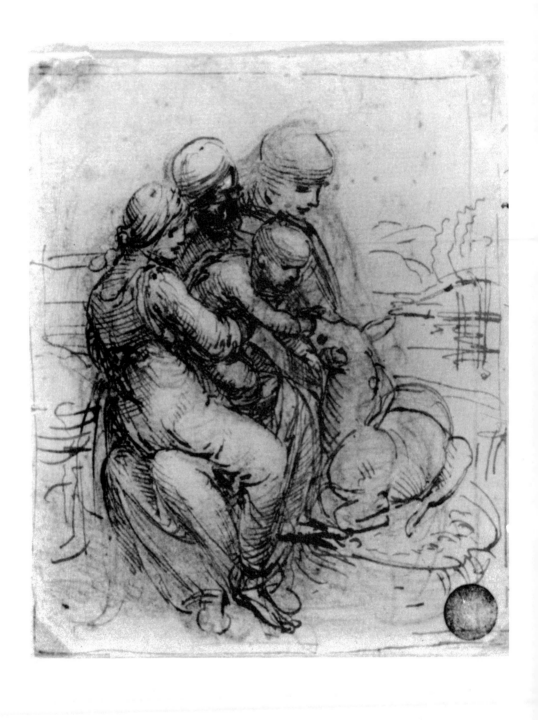

upon. The attitudes of bodies and all the parts of bodies should be drawn in such a way that one easily sees in them an attitude of mind.

You can sketch up compositions lightly, just attending to the posture of the figures, not bothering to finish a particular figure; this may be done afterward, at leisure, when you feel like it.

Positions of figures can be adapted to age or position in life, and they are to be varied also as to sex. The movement of age is not like that of youth, nor that of a woman like a man.

In a composition, it is wrong to repeat the same motions of figures, or the same folds in their draperies; or to make faces look alike.

In general, in painting historical subjects, there ought ordinarily to be very few old men, and they should be well set apart from young people, because after all, there are not so many old men and their habits do not agree with those of youth. Where customs do not conform, there can be no intimacy; and without intimacy the company is soon separated.

But if a subject requires gravity, let us say a meeting, a council, or other important business, don't bring in too many young men here, because youth willingly avoids such an atmosphere.

If the subject calls for a great number of figures, such as a

First study for The Madonna with St. Anne, *c. 1498–99. Accademia, Venice.*

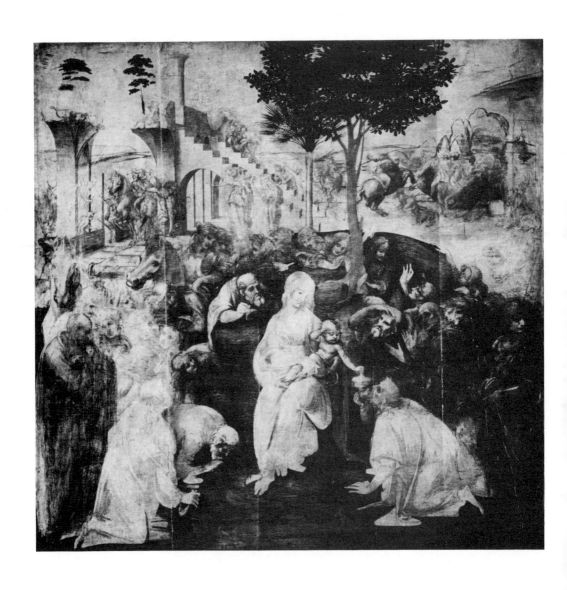

The Adoration of the Magi, *1481–82. Uffizi, Florence.*

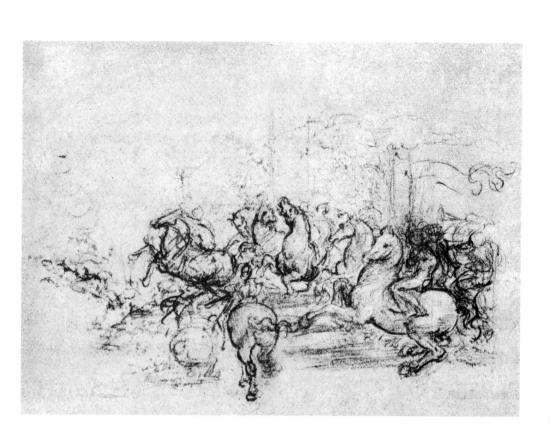

Studies of horsemen, c. 1503. Royal Library, Windsor Castle.

battle in which there are only three ways of striking, that is, thrusting, cutting, or slashing backhand, then all those that are cutting must be shown from a different angle, some turning their backs, some their sides, and others their fronts. And all three ways of fighting can be varied like this.

Great artistry can be displayed in battle scenes because of the complex motions which give spirit and life to the whole scene. By complex motion is meant, for example, a single figure showing the front of the legs, but at the same time the profile of the shoulder.

Always observe what is fitting. That is, action, dress, situation should accord with the dignity or lack of it of a subject. A king, for example, should be grave and majestic in expression and dress, and his surroundings should be elaborate. Attendants or bystanders should express reverence or admiration, and they too should be nobly attired, in costumes fitting to a royal court.

But, if you draw a mean subject, let the figure appear mean and despicable; and those about him should be meanly clad, with expressions and actions denoting their base and insolent minds.

In short, in both cases, the details should correspond with the general message of the painting.

Be careful how you mingle sad people with cheerful people. Nature has settled it that one weeps along with the sad and laughs along with the cheerful. Laughter and tears don't mix.

X Draperies

*Of these opinions of Leonardo's, nothing need
be said except that in an age when every artist
had to know how to draw angels and apostles,
and where even ordinary people liked to be
portrayed amid a flourish of rich stuffs, much
paint and pains went into draperies. Even today,
with our skimpier wardrobes, creases and folds
present subtle problems to the artist.*

The draperies which clothe your figures should be creased
in a way that accords with the parts they are meant to cover:
that is, falling gently over, describing the parts, and never
cutting into them with hard lines, deeper than the surface of
the body could possibly be.

Clothes should fit; they should not appear like empty
billows of cloth. This is a fault of many painters who fall in
love with folds in great quantity and variety, so that every-
thing is smothered in clothes, quite forgetting their purpose,
which is to surround the parts of the body gracefully, wher-
ever they touch, not fill with wind like bladders puffed up.

I don't deny that we have to introduce some handsome 103

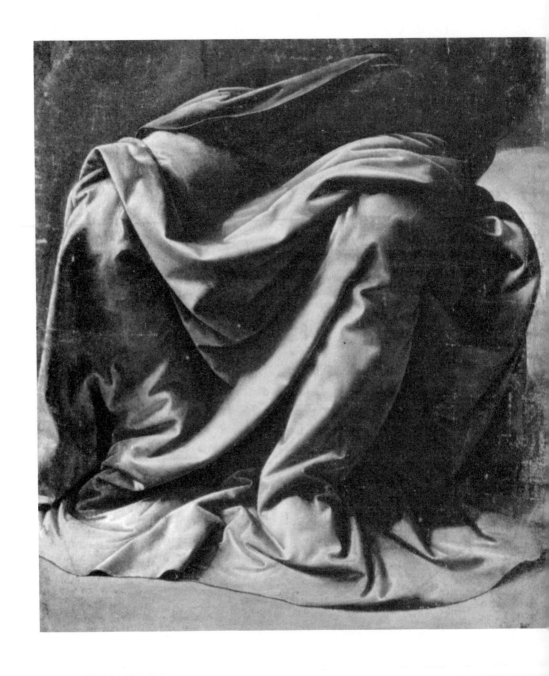

folds among our draperies, but this should be done with great judgment, and logically, so that the cloth is gathered naturally, according to the position and posture of limbs and body. Also, they should be drawn from nature. If woolen cloth is meant, the folds should be drawn after woolen folds; if it is silk or thin stuff, or very thick stuff such as laborers wear, let all these be distinguished by the nature of the folds. Never copy them, as some do, after models dressed in paper or thin leather, for this can be greatly misleading.

The folds of draperies need to be so drawn that whatever the motion of the figure, the mind of the beholder will have no doubt of it. If you represent the figures clothed with several garments, one over the other, the upper one should not appear to cover a mere skeleton; it should express the bulk beneath, as well as the flesh.

Draperies should not have too many folds and gathers. In fact, these ought to occur only where the cloth is bunched by the hands or slung over arms of the figures; the rest is left to fall with natural simplicity.

Study of drapery, c. 1480. Louvre, Paris.

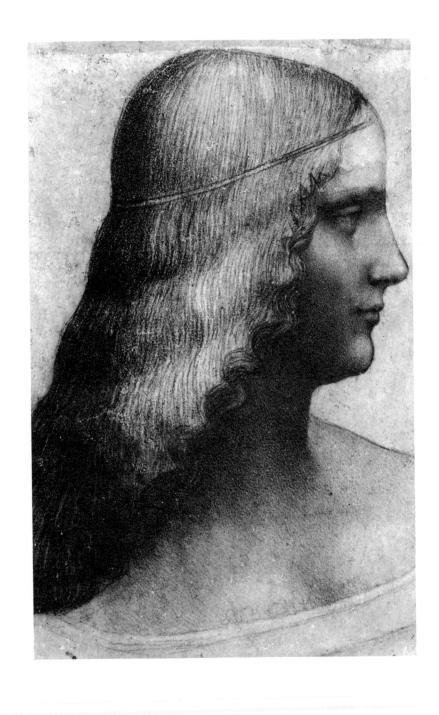

XI Light and Shadow

*"Let there be light," said God, thereby winning
Leonardo's hearty approval. "Of all the original
phenomena," he said, "light is the most
enthralling."*

*And no wounder he said so. Some philosopher
has defined the impossible as trying to catch a
black cat at midnight in a tunnel. But let the
smallest light be introduced, and the drama of
creation begins. First, shape becomes apparent,
then the dimensions and motion; and should an
artist applying himself to painting the scene
have studied well his chiaroscuro, he has the
delight of seeing every object detach itself
under his brush, acquire its own life, and appear
to move in relief.*

*An artist looking for an apartment will be
told with proud expertise by his real estate
agent, "Ah, I have just the thing—with a north
light." It is amusing to find this precept
emerging from Leonardo's notebook, shining
like new, but probably inherited from time
unimaginable.*

107

*Study for the portrait of Isabella d'Este, c. 1500. Stanley Leighton
Collection, London.*

The windows of your studio should look north so that the light will remain constant throughout the day. If it looks to the south it can be covered with paper blinds, so that the sun in its passage will not alter the shadows.

The best light to work in is when the shadow cast by your model on the ground is as long as he is tall.

There are two kinds of light. One is called original and the other derivative. Original light is that which comes from the sun or from the brightness of firelight or from the air. Derivative light is reflected light.

When studying a scattering of light on an object, observe which ones are brightest and how many; and the same for the shadows, which ones are darker than the others and how they blend together. Compare one with the other, their quality and quantity, and in what part of an object they do appear.

In drawing any object, outline is the most important; yet knowledge of it may be acquired pretty well by study, because the outline of an object, let's say the human figure, particularly those parts of it that do not bend, is invariable.

But knowledge of the quality and quantity of light and shadow cast on an object, since these are infinite, requires infinite study.

The first goal of a painter is to be able to make a simple flat surface appear like a relief, detached to some extent

from the ground. This is done by the correct use of light and shade. The one who can do this deserves the most praise.

Any painter who avoids the study of shadows can be accused of avoiding the glory of art itself, and his work will not be praised by anyone who knows anything about it.

A painter who wants to appear versatile should learn how to unite in the same composition objects that are shadowed both strongly and gently—of course, there must be a logical reason in every case for the use of such boldness and such softening.

Lights should be distributed according to the natural scene which your figures occupy. If they are in sunshine, the shadows are dark, the lights broad and extended, and the ground shadows of all objects very sharp. On a gloomy day there will be little difference between the lights and shadows, and no shadows appear at the feet. Indoors, lights and shadows are again distinct and shadows lie upon the ground; if the figures are lighted from a fire, the lights should be red and strong, the shadows dark, and the shadows cast on ground and walls, precise; but observe that they spread wider the farther from the body.

If figures are lighted partly by fire and partly by sky, the side receiving light from the sky will be brighter, the other side reddish, more or less the color of fire.

It is a great mistake for a painter to draw a figure from nature at home by any light that happens to be and afterward make use of the same drawing in a picture representing open

country, where the general light of the sky and the surrounding air is shed on all sides. This painter will put dark shadows where Nature puts none, or at least very faint ones; and he will throw sharp lights about where it is impossible that there should be any.

White appears whiter on a dark ground, dark darker on a light ground. When snow falls we see it darker against the sky; but seen through a window (owing to the darkness inside the house) it appears very white.

Note also how the snow seems to fall very quickly and thickly when near the eye, but at some distance seems to fall more slowly and there is less of it.

Place dark figures on a light ground and light ones on a dark ground. If, as is generally the case, it is partly light and partly dark, contrive that the dark part shows up against a light portion of the background, and the light part against a dark portion.

In moderate light, there is not much difference between light and shade. Works painted in such a light. at the fall of evening or when there are clouds, are soft in feeling, and every kind of face acquires a charm.

Watch how, where a shadow ends, there is always a kind of half-shadow to blend it with the light. The farther a shadow stretches from the object which casts it, the broader is that blending at the edge.

If you want to represent great darkness, you must do it by creating contrast with light; and on the contrary, great brightness must be opposed to something of very dark shade.

A white object receiving light from the sun or air will have bluish shadows.

Light and Shadow

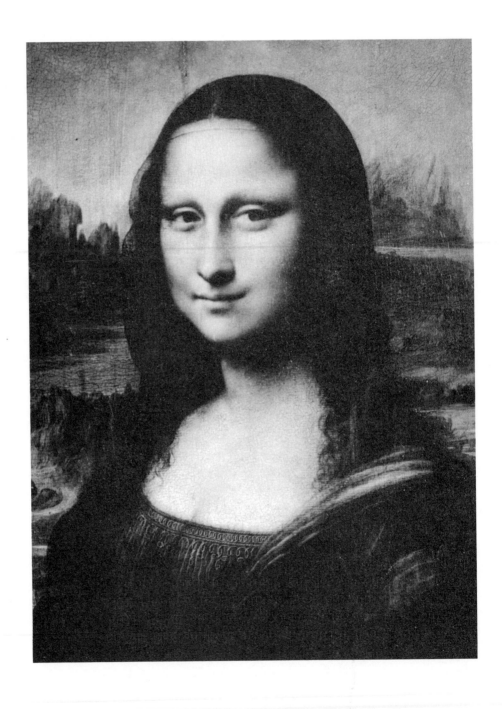

XII Color

As I have mentioned, Leonardo did not let his pupils use color until they had reached what would have seemed to them a ripe age. It must have been particularly galling for them as Latins, if the theory is correct that the more southerly people of Europe, by temperament, enjoy color more than do the northern peoples.

Today, no matter where you come from, you can go to an art store and indulge yourself in any color and mixture of colors without end. Leonardo had to mix his own, and he took careful notes on everything he did.

"Mixing verdigris with an amount of Caballine aloe bestows a great measure of beauty; still more from saffron, but saffron tends to fade. The quality of this aloe, however, is proved when you dissolve it in warm brandy; then, having already used the verdigris and finished the detail, you might glaze it over thinly with this dissolved aloe and produce a very fine color. You can also grind it into the oil itself, 113

Mona Lisa *(detail), 1503. Louvre, Paris.*

Leonardo da Vinci's Advice to Artists

or do it along with the verdigris or any other color."

After an artist had made a sketch of an intended painting, Leonardo recommended that he give the surface a good thick priming with pitch and brick dust, well-pounded. Next, he suggested a second coat of white lead and Naples yellow. The finished painting then had to be perfectly dried in a stove and varnished with nut oil and amber, or else with purified nut oil that had been thickened in the sun.

Carried away by all these precious exactitudes, Leonardo made the mistake of confiding them to the Medici pope, Leo X, from whom he hoped to obtain a commission. The pope commented, "This man will never get anything done, because he thinks about the end before he begins."

This remark shows the pope's acumen as a businessman, because it was certainly Leonardo's besetting sin that he thought so greatly and did so little, but it is heart wringing that this pope, who could have bestowed some great commission on an immortal genius, ended up by ordering Leonardo to rebuild his brother's stables for twenty-eight horses.

When Leonardo left Italy to enter the service of the king of France, he said, "The Medici made me and broke me."

What is beautiful is not always well and good. I submit this thought to painters who are so attached to the beauty of colors that they hate to put the least shadow on them, giving not a thought to the beautiful relief given to figures by a proper gradation and strength of shadow.

Such painters remind me of speakers who use many fine words with little meaning, and which together form hardly one good sentence.

Things that have a dull surface show their natural color best; for example, cloth, or those leaves and grasses that, having no luster, exhibit their full color to the eye—unless it happens that the color is confused by a reflection of an opposite color, such as the setting sun.

Opaque objects exhibit their color most perfectly if nearby is another object of the same color.

The first of all simple colors is white, although some would not admit that either black or white are colors, the first being a source or a receiver of colors, and the latter totally deprived of them. But we can't leave them out; since painting is but an effect of light and shade, that is, chiaroscuro. So white is the first, then yellow, green, blue, red, and finally black. White may be said to represent light, without which no color can be seen; yellow the earth; green, water; blue, air; red, fire; and black is for total darkness.

If you wish to see quickly and easily the entire scope of mixed or composed colors, take some plates of colored glass and look through them at the country around: you will find that the color of each object is modified by the color of the

glass. Note, then, which is improved and which hurt by the mixture. If the glass is yellow, then the blacks and whites will be greatly impaired, while the greens and yellows will be brightened. You can go through all the mixtures of colors this way: they are infinite. Note those which are novel and beautiful, and go on with two glasses, or three, until you have found what will best answer your purpose.

Let us consider when any color may show up in perfect purity, whether in strong light or deep shadow, in demitint or in reflection. Different colors behave differently in this respect. Black is most perfect in shadow, white in strongest light; blue and green in half-light, yellow and red in the principal light; gold in reflection; and lake in half-light.

The truest color of an object shows up in whatever part is not occupied by either light—if it is a glossy surface—or shade.

Any color is more distinctly seen when opposed to its contrary: thus, black on white, blue near yellow, green near red, and so on.

White encroaching with a sharp edge on a dark ground will make the dark part near the point of contact appear darker; and the white appears whiter.

Anything white seen in a dense air full of vapors will appear larger than it is in reality.

The air that exists between the eye and the object seen

will change the color of that object into its own; just so will the azure of the air change distant mounts into blue masses. It is just like looking through a red glass, when everything appears red.

When a transparent color is laid on another color, the result is a composite, different from either of the original simple colors. For example, smoke emerging from a chimney along with black soot appears bluish, but as it ascends against the blue of the sky it changes to a reddish brown. The color lake laid on blue will turn violet; yellow upon blue turns green; saffron upon white becomes yellow; white spread thinly on a dark ground will appear blue, and this is more or less beautiful according to the purity of the white and the ground.

Firelight tinges everything around it reddish yellow, but this will not show up well unless the contrast is made with daylight. A scene at twilight in the evening, for instance, will emphasize this, and even better one just at dawn, especially in a dark room when a little ray of daylight strikes any part, and there remains but a candle burning.

Though you may not actually increase the natural beauty of colors, yet by placing them together they may lend added grace to each other. Red shows up beautifully against pale yellow; not so against a purple color. Green shows up next to red, not so next to blue.

Of two objects equally light, one will seem less so if put

Leonardo da Vinci's Advice to Artists

against a lighter ground, and a great deal more so if placed on a darker ground. Flesh color looks pale on a red ground; any pale color looks redder on a yellow ground. In short, colors seem to be what they are not, according to the surroundings.

A reflected color is less brilliant than one receiving direct light in the same proportion as the directly lighted color is less brilliant than the source of light.

XIII Landscape

Leonardo's interest in landscapes and the
growing things that decorate them goes back to
his early youth, when he collected and drew
herbs, flowers, and leaves. His passion for this
hobby led him to collect species after species,
and he kept them all in a separate room
together with his animals.

The earliest sketch we have by Leonardo is a
pen drawing of a mountain landscape, his
recollection of a scene of his childhood. He
climbed every rocky path around Vinci; he
knew the woodland in every season. One day
he would write: "What moves you, O man, to
leave your shelters in the city, to leave relatives
and friends and go into the open country, up
mountains and down valleys, if not the natural
beauty of the world?"

He rode the countryside past cliffs and crags
to "shady valleys watered by merry winding
streams." Caught in a shower, he seized the
opportunity to sketch the rain bursting from
the clouds and beating down in a sheet of water. 119

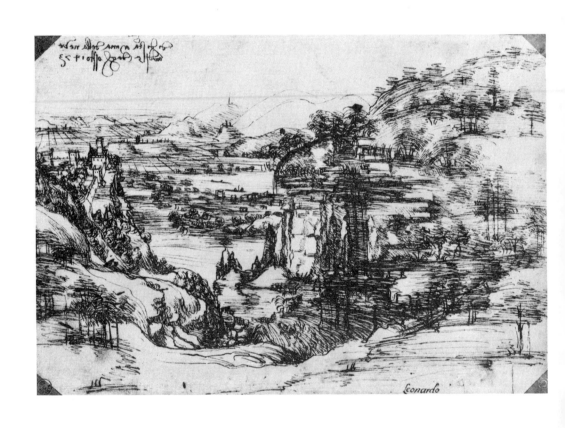

Landscape, 1473. Uffizi, Florence.

Of course, his drawings of objects of nature Landscape
are superlative; with no color at all they utterly
engross the eye.

A painter cannot be said to aim at universality in art unless
he loves equally every aspect of art. For instance, if he occu-
pies himself only in landscapes, he might draw the criticism
of our friend Botticelli, who remarks that by throwing a
sponge soaked in various colors at a wall, the stains left can
easily appear like a landscape.

It is true that one may see all sorts of things in such spots,
according to fancy: the heads of men, animals, battles, rocky
scenes, seas, clouds, woods, and so on—just as in the sound of
bells we may hear whatsoever we choose to imagine. In the
same way these spots give hints at compositions. But they do
not teach us how to finish any detail, and any painter who
tried to paint a landscape after stains would be a sorry
landscape painter.

To paint landscapes, choose a time when the sun is at the
meridian, set yourself facing west or east, and begin your
work. The vivacity of colors in a landscape painting will
never bear comparison with the natural colors illumined
by the sun, unless the picture is placed so as to receive the
same light from the sun.

Contrive that the trees in your landscape be half in shadow
and half in light. It is better to show them as if under a sun 121

veiled with clouds, because the trees then receive a general light from the sky and are darkest in those parts which are nearest the earth.

Of greens seen in the country, that of trees and shrubs will appear darker than the green of fields or meadows.

Greens appear nearer blue the more remote they are from the eye.

Short grass growing beside gravel exhibits different colors according to the differing fertility or barrenness of the soil; therefore some of it appears blackish or yellowish or greenish brown, or perhaps greenish yellow or again greenish blue; and thus it is all different.

The thickest tips of the branches of trees send out larger and more numerous leaves than do the ends of other branches.

The upper branches of trees are more heavily covered with leaves than the lower ones.

The shadow of a bridge is not seen on the surface of the water unless the water is troubled and murky; because clear water, being polished and smooth, reflects the image of the bridge, as in a looking glass. But when the water is muddy and the transparent and reflecting quality is lost, it receives the shadow of the bridge, just as a dusty road would.

The setting sun is a beautiful and magnificent sight when it tints with color all the buildings of towns, villages, and the tops of high trees. All beneath it seems blurred, almost lost in the tender, diffuse mass, for, lighted only by the air, the difference between shadow and light diminishes, and objects seem barely detached from one another—except those high ones that are touched by the rays of the sun and tinged with its color. The painter should therefore use the same color with which he has painted the sun in touching all those parts of his work that receive its light.

In showing objects on a landscape, barely indicate the more remote ones, and as they come closer make them more distinct. That is, objects seen at a distance should be only sketched and left unfinished, delicately colored. Objects close to the observer must show firm color.

When the sun tinges the clouds along the horizon with red, those objects which have a bluish hue on account of their distance will partake of the red, producing a mixture of azure and red, rendering the view very pleasant; and every solid object that receives that light will show up distinctly and redly; and the air, being transparent, will be impregnated with it and appear the color of wild lilies.

Air seen between the earth and the rising or setting sun will always dim the objects it surrounds more than air anywhere else, because it is whiter.

In showing the movement of wind, besides the bending of

trees and the leaves twisting wrong side up, you might also express the small dust clouds whirling aloft and mingling confusedly with the air.

Dust becomes lighter the higher it rises. When it is seen between the eye and the sun, it appears darker the less it is raised.

Movements of air come about through changes in humidity of the atmosphere.

Smoke seen between the sun and the eye seems lighter and more transparent than any other thing in the landscape. The same is true of dust and fog. On the other hand, if you place yourself between the sun and those objects, they will appear dark.

The sunbeams which stream through the openings between clouds of various density and form illuminate everything they pass over, at the same time tinging with their own color all the dark places they do not touch directly, and which are seen only in the intervals between the rays.

When the rain is just beginning to fall, it tarnishes and dulls the air, yet on one side still receives a faint light from the sun, though shaded on the other side like clouds. Gradually it darkens all the earth, depriving everything of the sun's light.

Objects seen through the rain appear confused and of indeterminate shape; those which are near will be more

distinct. You may note too that objects are more distinct on the shadier side because on that side they have lost only their principal lights, while on the other they lose both light and shadow, the lights mingling with the glitter of the rain and the shadows considerably weakened by it.

Smoke is more transparent, though darker, toward the extremities of its billows than in the center. It moves obliquely according to the force of the wind. Different kinds of smoke vary in color, according to the causes, which are various.

Smoke does not produce definite shadows, and the extremities fade as they draw away from the source. Objects behind are seen in proportion to the heaviness of the smoke. It is whiter toward the source, bluer toward the edges.

Fire appears darker the more smoke is interposed between it and the eye.

Smoke smothers and dims all landscape like a fog. It is seen emerging from different places, with flames at the source, where it is densest. The tops of mountains appear more distinctly through it than do the lower parts, exactly like fog; and when smoke emerges far off, objects are less blurred by it.

When the sea is a little ruffled, its color changes; looking from the shore it appears of dark color, and darker still as it stretches toward the horizon, and furthermore, lights can be seen moving across its surface like a flock of sheep.

Looking at the sea from aboard a ship some distance from land, it seems blue. Nearer the shore it appears darkish on

account of the color of the earth reflected by the water as in a looking glass; but at sea, the blue of the air is reflected.

If the painter has to show a spot covered by water, he should remember that the color of it cannot be of either a lighter or a darker shade than that of the neighboring objects.

The stronger the current of a river, the more the water weighs, and the more it weighs, the faster it plunges in descent, and the faster it plunges, the harder it hits an object.

Water always slows down before an obstacle, and the sand in the bottom becomes wavy.

A current carrying foreign matter, upon approaching a stagnant pool, loses strength and unloads material at the entrance of the pool.

The whirls and eddies of a river seem to have something of the nature and force of a screw which no strength or solidity can long resist.

When a smaller river pours into the dammed-up waters of a larger river, then the smaller river will send its water along a straight line toward the center of the larger river.

Water falling from a cloud sometimes dissolves into such tiny particles that meeting the friction of the air, it cannot pierce the air, but seems itself to become air.

Objects seen between light and shadow will appear in greater relief than objects seen in full light or full shadow.

The outlines of distant objects appear indeterminate and confused. If you make them too sharp and strong, they will appear near. Make your painting give a correct idea of distances. If in nature the object appears blurred in outline, let it be blurred in your picture.

In autumn, depict things according to the progress of the season. In the beginning it is only the leaves of the oldest branches that commence to fade, more or less depending on whether the tree is growing in sterile or fertile soil. Even paler or more reddish are the leaves of trees that were first to produce fruit.

Do not imitate those painters who show every kind of tree, even those equally distant, in the same shade of green. Vary the colors, fields, plants, stones, tree trunks, and all other objects, for Nature abounds in variety. Even on the same plant you will note differences in color; for instance, on the willow whose longer and more beautiful leaves are found on the upper branches. Nature is so lovely and variable that plants, even of the same species, never . . . closely resemble each other, and this is so not only of any plant as a whole; even in the individual branches, leaves, fruit, never is one precisely like another.

Observe all this and vary them therefore.

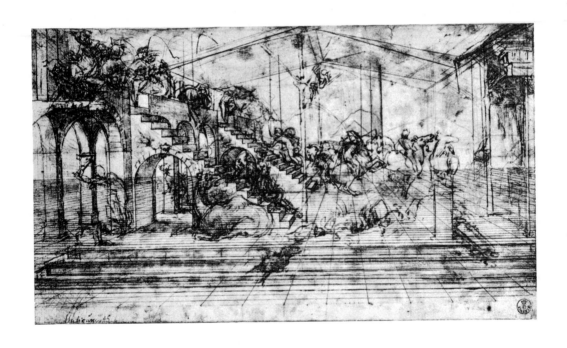

Study for the background of The Adoration of the Magi, *c. 1481.*
Uffizi, Florence.

XIV Perspective

Here we have the dry matter of the art lesson,
the tough stuff that takes all the fun and feel out
of learning how to draw, the part that deprives
the world of so many great artists, because they
get discouraged and bow out. There was a time,
in centuries past, when no one knew anything
about perspective, and no artist had to
understand it. Then there came a time when
they did understand it, and it was part of their
art. Between the two periods stood artists like
Leonardo, incessantly observing in their solitary
way the phenomena of vision, excavating from
nothing a body of knowledge about the way we
perceive visible objects, and then defining laws
to pass on to others. Thus Leonardo would
distinguish between "thin" and "thick" air—
according to the moisture content—and note
how it distorted perspective, and how colors
changed with distance, and much that we now
learn by rote.

Leonardo had no doubt at all that such
scientific research was as much a part of the
artist's equipment as his brushes, and he said so

Leonardo da Vinci's
Advice
to Artists

unequivocally. He felt that anyone who thinks he can practice art without diligently studying the scientific side of it can be compared to a crew of sailors who put out to sea in a ship without rudder or compass and therefore have no hope of arriving at the desired port.

There are three aspects to perspective. The first has to do with how the size of objects seems to diminish according to distance; the second the manner in which colors change the farther away they are from the eye; the third defines how objects ought to be finished less carefully the farther they are away.

Bodies of equal size diminish according to distance from the eye and every object loses first its slenderest portions: that is, a horse would lose its legs sooner than the head because the legs are thinner; and it would lose the neck before the trunk for the same reason. It follows that the part of the horse the eye would see last would be the trunk.

Of objects of equal size equally distant from the eye, the one that catches the most light will appear largest.

Of equal objects equally distant from the eye, the darkest will appear smallest.

Linear perspective follows established rules giving the dimensions of objects according to their respective distances from the eye; the second object being smaller than the first, the third than the second, and so on until at last they become invisible.

Objects of less magnitude are the first to vanish from sight; this is because the shape of small objects comes to the eye from a more acute angle. It follows that when large objects, removed to a great distance, and therefore striking the eye at a small angle, are barely visible, smaller objects will have entirely disappeared.

The size of a figure in a composition should denote the distance at which it is situated. If a figure is shown in natural size, that would denote its being near the eye.

A student should early acquire a knowledge of perspective to enable him to give every object its proper dimensions; then, he should have a good master who will gradually teach him a good style of drawing. Next, he should study Nature, in order to confirm and fix in his mind the reasons for the rules he has learned; and also give some time to the study of old masters in order to form his eye and judgment, so that he may put into practice what he has learned.

A study of perspective should be in the forefront of all human disciplines . . . for in it you will find the glory, not only of mathematics, but of physics.

Perspective is to painting what the bridle is to the horse, the rudder to a ship.

There is a kind of perspective called aerial perspective, which depends on the differences in the thickness of the air. Suppose, for example, you want to place a number of buildings behind a wall, all appearing about the same height above it; but you must show some more distant than others. You must then suppose that the air between the more distant buildings and the eye to be somewhat thicker. Seen through such thick air any object—you can see the case with mountains, for example—will appear bluish.

You will then paint the first building behind the wall in proper contour and proper color; the next distant will be less distinct in outline and will participate more in the bluish tint. Another, set off much farther, is painted much bluer, and if one building is five times farther back from the wall, it must be five times more blue.

In this way buildings actually drawn the same size in the same line will be distinctly set off as being of different distances from the eye.

Objects distant from the eye appear smaller than they really are, and because there is a great quantity of air interposed, the appearance of forms is weakened, and we are prevented from seeing minute details. The painter, therefore, should sketch in such details but lightly, otherwise the effect will be contrary to Nature, his chosen guide.

Buildings seen far off in the morning or evening, when mists

arise, or thick air, are seen distinctly only in the parts lighted by the sun. The parts of buildings not turned toward the sun remain confused, and almost the color of the mist.

When a tall building quite close to the eye is seen through a mist, the top parts will appear more confused than the bottom because there is more mist between the eye and the top. A square tower seen at a distance through a mist will appear narrower at the base than at the summit.

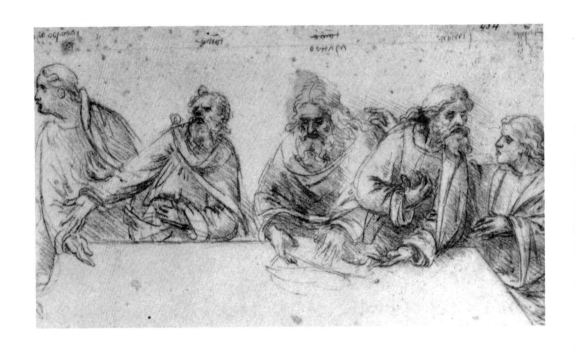

School of Leonardo: Study for The Last Supper *(detail), 1495–97.*
Accademia, Venice.

XV Judging One's Own Work

Leonardo was immensely self-critical, perhaps too much so; if he had not been, we might have had more than the very few masterpieces from his hand that remain to us. Then, again, such masterpieces would not have been painted by the man Leonardo as we know him.

We know of his anguish while he painted "The Last Supper" on the wall of the monastery of Santa Maria delle Grazie in Milan. In the middle of the work he would sometimes remain absent from it for days. When he returned, it might only be to stand motionless, perhaps for hours, looking at his fresco with folded arms. Then, without once reaching for his brush, he would go away, deep in thought, his brow wrinkled as if in pain.

Then, sometimes, while working at home, he would suddenly jump up, rush out into the street, hurry to the monastery, leap onto the scaffolding, seize the brush, and make a few strokes. Then he would return homeward with the quiet, satisfied smile of a man who has done his day's labor.

135

Leonardo da Vinci's
Advice
to Artists

*From these agonies came the work we regard
as the greatest art treasure of the Western
world. Thirteen figures are shown on it, every
one of which reflects, in large and in detail, all
the precepts you may read in this book. But the
central face, the face of Christ, was never
finished.*

*In his notebook Leonardo scribbled a random
note that might be taken as an explanation to
posterity for his small output:*

> *"When a work is equal to a painter's ability
> to judge it, this is a bad sign; and when the
> work happens to turn out better than the
> judgment, this is even worse. It is exactly the
> case of those people who are always
> wondering why they have succeeded so well
> in what they do.*
>
> *But when judgment is higher than the
> work, that is a very good sign. A young
> painter who possesses this scarce faculty will
> eventually come to perfection. He may
> produce few works, but they will be such as to
> transfix every beholder with admiration."*

If on your own or by the criticism of others you discover
error in your work, correct it then and there; otherwise,
in exposing your work to the public, you will expose your

error also. Don't make excuses, persuading yourself that you will retrieve your reputation in some future work, because your work does not fade when it leaves your hands like the sound of music, but remains a standing monument to your ignorance. If you protest that you have not time to take pains necessary to be a great painter, having your living to make, you have only yourself to blame: for the study of what is excellent is food for mind and body.

A philosopher born to great riches will give them all away rather than be deflected for a moment from his true pursuit.

It is a well-known fact that we see the faults in others' works more readily than we do in our own. It is a good idea therefore for a painter to have a looking glass nearby when he paints, so placed that he can often see his work in it, which, seen in reverse, will appear to be the work of another hand and thus will better show up his mistakes.

It will be useful too if he quit work often and take some relaxation; judgment will be clearer upon his return. Too great application and sitting still is sometimes the cause of gross errors.

Nothing is more apt to deceive us more readily than our own judgment of our work. We derive more benefit from having our faults pointed out by our enemies than from hearing the opinions of friends. Friends are too like ourselves: they deceive us as much as our own judgment.

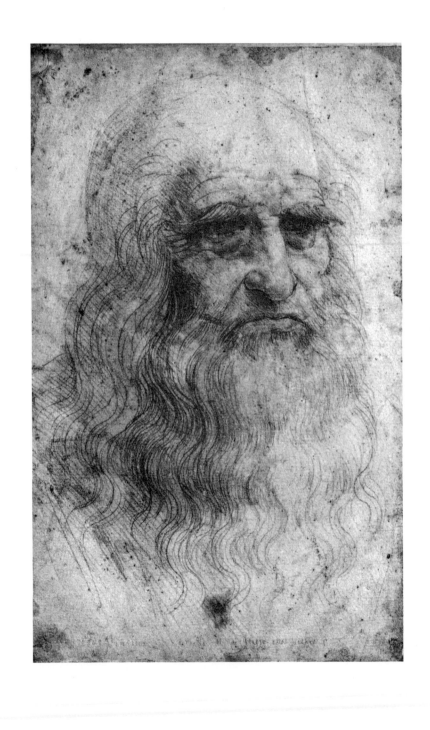

A painter should not object to listening to the opinion of a layman. Even if a man is not a painter, he knows what the human form looks like and whether a man has, let's say, a hump or a thick leg or a large hand, or whether he is lame or has a large mouth or nose or anything else. If someone is quite capable of judging the works of Nature, shouldn't we admit him capable of detecting our errors?

Judging One's Own Work

Self-portrait, c. 1512. Biblioteca Reale, Turin.

Bibliography

Freud, Sigmund, *Leonardo da Vinci and a Memory of His Childhood*. New York: W. W. Norton, 1964.

Gallenberg, Hugo von, *Leonardo da Vinci*. Leipzig, Germany: F. Fleischer, 1834.

Leonardo da Vinci. New York: Reynal and Company, 1956.

MacCurdy, Edward, *Leonardo da Vinci's Notebooks*. London: Duckworth Company, 1906.

MacCurdy, Edward, *Notebooks of Leonardo da Vinci*. New York: Reynal & Hitchcock Inc., 1939.

Müntz, Eugène, *Leonardo da Vinci*. London: William Heinemann, 1898, 2 vols.

Pedretti, Carlo, *Leonardo da Vinci on Painting*. London: Peter Owen, 1965.

Richter, J. P., *The Literary Work of Leonardo da Vinci*, revised by S. A. Richter. London: Oxford University Press, 1883.

Rigaud, John Francis, *Treatise on Painting*. London: G. B. Nichols and Son, 1802.

Vallentin, Antonina, *Leonardo da Vinci*. New York: The Viking Press, 1938.